How to Start an Antique Booth Business

Your Ultimate Guide to Profitable Vintage Selling

Jeanelle K. Douglas

Copyright © 2024 by Jeanelle K. Douglas.

All rights reserved.

DEDICATION

To the reader who holds this book. You hold the key to unlocking this journey.

Thank you for joining me.

Contents

Introduction ... 8
 Overview of the Antique Booth Business 11
 Potential Market and Opportunities 13
Planning Your Antique Booth Business 20
 Understanding the Antique Market 23
 Identifying Your Niche ... 26
 Market Research and Analysis 28
 Setting Business Objectives and Goals 32
Legal and Financial Considerations 35
 Choosing the Right Business Structure 38
 Obtaining Necessary Licenses and Permits 41
 Insurance for Your Antique Booth Business 45
 Setting Up Your Business Bank Account and Accounting System ... 48
 Understanding Tax Obligations 52
Sourcing Antique Items .. 56
 Tips for Buying Antiques ... 59
 Verifying Authenticity and Value 62
 Building Relationships with Suppliers 65

Setting Up Your Antique Booth ... 69
 Selecting the Right Location .. 71
 Creating an Inviting Atmosphere ... 78
 Display Techniques for Antiques .. 81
Pricing Your Antiques .. 84
 Factors Influencing Antique Prices .. 87
 Pricing Strategies for Your Items ... 90
 Negotiation Tips with Customers ... 93
Marketing and Promotion ... 96
 Branding Your Antique Booth .. 99
 Effective Marketing Strategies ... 102
 Utilizing Social Media for Promotion .. 105
 Networking in the Antique Community 108
 Participating in Antique Shows and Events 111
Sales and Customer Service ... 114
 Selling Techniques for Antique Dealers 117
 Enhancing Customer Experience ... 120
 Managing Customer Inquiries and Complaints 123
 Building Customer Loyalty ... 127
Online Sales and Presence .. 130

- Creating an Online Store for Your Antiques 133
- Online Marketplaces for Antique Sales 136
- Digital Marketing Strategies for Online Sales 139
- Managing Online Customer Service .. 142

Managing Your Inventory .. 146
- Inventory Management Techniques .. 149
- Tracking Your Stock and Sales ... 152
- Balancing Your Inventory Mix .. 156

Financial Management .. 159
- Setting Up and Managing Your Budget 162
- Financial Planning and Forecasting ... 165
- Profit Maximization Strategies ... 168
- Handling Cash Flow Challenges .. 172

Expanding Your Business ... 175
- Growth Strategies for Antique Booth Businesses 178
- Exploring Additional Revenue Streams 182
- Franchising or Opening Additional Locations 185
- Collaborations and Partnerships .. 188

Challenges and Solutions ... 191
- Maintaining a Competitive Edge .. 199

Conclusion ... 203

Encouragement for Future Antique Dealers 205

Introduction

Starting an antique booth business is an exciting venture for anyone with a passion for history, art, and the thrill of the hunt. This journey combines the joy of discovering hidden treasures with the satisfaction of entrepreneurship, offering a unique path to business ownership that is as much about curating a collection as it is about customer service and salesmanship. The allure of antiques lies not just in their aesthetic appeal or rarity, but in the stories they carry and the glimpses into past lives and eras they offer. As a result, the antique booth business attracts a diverse clientele, from serious collectors and decorators to casual shoppers and history enthusiasts.

Embarking on this venture begins with understanding the antique market, a vibrant and ever-changing arena where trends can shift with the seasons. Success in this business requires more than just an eye for valuable items; it demands an in-depth knowledge of what makes an item desirable, be it its historical significance, craftsmanship, condition, or rarity. Identifying your niche within this broad market is crucial, as it allows you to focus your efforts and develop expertise in specific areas, whether that be furniture, vintage clothing, jewelry, or any other category of antiques.

Market Research

Market research is the foundation upon which your business will be built. This involves not only understanding the types of antiques that are in demand but also identifying your potential customers and competitors. It's about finding the right balance between what you love and what sells, ensuring that your passion also translates into profitability. Setting clear business objectives and goals is an essential next step, providing you with direction and milestones to measure your progress.

The antique booth business is not just about what you sell, but how and where you sell it. Selecting the right location for your booth, whether in an antique mall, at flea markets, or at special events, is pivotal to your visibility and accessibility. Your booth's design and layout play a significant role in attracting customers, making it important to create an inviting and intriguing space that highlights the uniqueness of your items.

In this business, your inventory is your greatest asset. Sourcing antique items is an art in itself, requiring you to build a network of suppliers, attend estate sales, auctions, and flea markets, and even delve into online marketplaces. The thrill of the hunt is a significant part of the allure of the antique business, with each find adding not only to your inventory but to the unique character of your booth.

Pricing

Pricing your antiques correctly is another critical aspect of the business, requiring a balance between the item's worth, its market demand, and your own investment in it. This often involves negotiation, both when purchasing items and when selling them, making interpersonal skills as important as your knowledge of antiques.

Marketing and promoting your antique booth is essential in today's competitive market. This goes beyond traditional advertising, encompassing branding, social media presence, and community engagement. Building relationships with your customers through exceptional service and knowledge sharing can turn casual shoppers into loyal patrons.

The journey to starting an antique booth business is filled with challenges and opportunities. It requires a combination of passion for antiques, business acumen, and the ability to adapt to market trends. However, for those willing to invest the time and effort, it offers a rewarding path to entrepreneurship, allowing you to turn your passion for the past into a promising future.

Overview of the Antique Booth Business

The antique booth business is a fascinating intersection of commerce, history, and artistry, offering entrepreneurs a unique opportunity to engage with history and culture while pursuing a passion for collecting and selling. At its core, this business model involves curating a selection of antique and vintage items to sell in a dedicated space, often within an antique mall, market, or fair. These booths serve as both a retail outlet and a showcase for the dealer's eye for valuable, rare, or historically significant items, ranging from furniture and artworks to jewelry and collectibles.

Antique booths operate within a larger ecosystem of antique malls, flea markets, and specialty shows, where multiple dealers set up shop under one roof or within a designated area. This collaborative environment not only draws a diverse array of customers but also fosters a community of dealers and collectors who share knowledge, resources, and sometimes even inventory. The nature of the business allows for significant flexibility in scale, investment, and focus, making it accessible to both seasoned collectors and those new to the antiques world.

One of the key attractions of the antique booth business is the treasure hunt aspect—both for the dealer and the customer. Dealers

spend considerable time researching, sourcing, and acquiring items that they believe will captivate their customers, often traveling to estate sales, auctions, and other venues to find the perfect pieces. This aspect of the business requires a keen eye, deep knowledge of historical periods and styles, and an understanding of current market trends and customer preferences.

Pricing and presentation are critical components of success in the antique booth business. Dealers must expertly assess the value of their finds, considering factors such as rarity, condition, provenance, and market demand, to price items in a way that is both competitive and profitable. Furthermore, the way items are displayed within the booth can significantly impact sales; effective presentation not only highlights the individual beauty and uniqueness of each piece but also tells a story that engages customers and encourages them to make a purchase.

Marketing and customer relations play a significant role in the antique booth business. Building a brand around one's booth, leveraging social media, and engaging with customers through storytelling and shared enthusiasm for antiques can help attract repeat business and establish a loyal customer base. Participation in antique shows, flea markets, and other events also serves as a vital marketing tool, expanding the dealer's visibility and reach.

The antique booth business is not without its challenges, including fluctuating market trends, the need for continuous inventory sourcing, and the logistics of booth management and operation. However, for those with a passion for antiques and a knack for business, it offers a rewarding and dynamic entrepreneurial opportunity. Success in this field is marked not just by profitability, but by the joy of connecting people with pieces of history and preserving the stories of the past for future generations.

Potential Market and Opportunities

The potential market and opportunities within the antique booth business are both vast and varied, influenced by factors such as changing consumer interests, the rise of online marketplaces, and the increasing appreciation for sustainable and unique home decor. This sector attracts a wide audience, from serious collectors and interior designers to casual shoppers looking for unique pieces to enhance their living spaces. Understanding these diverse customer segments and the evolving landscape of the antique industry is crucial for identifying and capitalizing on the opportunities available.

Expanding Customer Base

The market for antiques and vintage items has seen a notable shift with the entrance of younger generations, such as Millennials and Gen Z, who are drawn to the sustainability aspect of buying vintage and the unique character that antique pieces add to their homes and wardrobes. This growing demographic represents a significant opportunity for antique booth businesses to expand their customer base by curating collections that appeal to these younger shoppers' aesthetic preferences and values.

Online Sales Channels

While traditional brick-and-mortar booths remain at the heart of the antique business, the rise of online sales channels has opened up new avenues for reaching customers. Platforms such as Etsy, eBay, and Instagram allow dealers to showcase their collections to a global audience, increasing their sales potential and brand visibility. Embracing these online opportunities, alongside a physical booth, can create a complementary sales approach that maximizes revenue and market reach.

Niche Markets

Specializing in a particular niche or type of antique can be a highly effective strategy for standing out in a crowded market. Whether it's vintage fashion, mid-century modern furniture, rare books, or

collectible toys, focusing on a specific niche allows dealers to build expertise and reputation, attracting customers seeking knowledge and quality in that area. This focus can also help in creating a cohesive and attractive booth presentation, drawing in customers who share a passion for the niche.

Experiential and Community Events

Antique booths and markets are increasingly recognized not just for shopping but as cultural and community experiences. Hosting or participating in events such as antique fairs, themed markets, workshops, and talks can attract a diverse audience and create a sense of community among customers and dealers alike. These events offer opportunities for engagement beyond the transaction, building customer loyalty and word-of-mouth promotion.

Sustainable and Ethical Consumption

The growing awareness and concern for sustainability and ethical consumption practices have bolstered the appeal of antiques and vintage items as environmentally friendly alternatives to mass-produced goods. This shift in consumer values presents a significant opportunity for antique dealers to highlight the sustainability aspect of their business, appealing to environmentally conscious shoppers and differentiating themselves in the market.

Interior Design and Prop Rentals

Collaborating with interior designers, event planners, and film and television production companies can open up additional revenue streams for antique booth businesses. These professionals are often in search of unique pieces to complete a design project or set, providing opportunities for rentals or sales of high-value items.

Success Stories in the Antique Booth Industry

The antique booth industry is dotted with numerous success stories that not only inspire but also shed light on the varied paths entrepreneurs can take to achieve profitability and recognition in this unique market. These stories often begin with a deep passion for history, a keen eye for unique items, and the perseverance to build a brand in a competitive landscape. Here are some illustrative examples of success in the antique booth business, reflecting the diversity and potential within the industry.

Transforming Passion into Profit

One notable story is that of a couple who turned their weekend hobby of visiting estate sales and auctions into a full-fledged business. Initially renting a small booth in a local antique mall, they focused on curating a collection of mid-century modern furniture and decor, a niche they were personally passionate about.

Their keen eye for quality and design, combined with effective storytelling about the history and value of their pieces, quickly attracted a loyal customer base. Expanding their presence online through social media and an e-commerce site, they were able to grow their business beyond the confines of their booth, eventually opening their own store and becoming a go-to source for mid-century modern enthusiasts.

Leveraging Online Platforms

Another success story comes from an individual who started selling vintage clothing and accessories from a small booth in an antique market. Recognizing the growing demand for vintage fashion among younger generations, they expanded their business to include online sales through platforms like Etsy and Instagram. By showcasing their unique finds through engaging content and leveraging the global reach of these platforms, they were able to significantly increase their sales and visibility, eventually launching their own brand of reimagined vintage clothing.

Building a Brand around Sustainability

A dealer specializing in antique and vintage home decor has made a name for themselves by focusing on the sustainability aspect of their business. By promoting the idea that purchasing antiques is a way to reduce environmental impact, they attracted a customer base that

values eco-friendly lifestyle choices. Hosting workshops on sustainable home decorating and participating in green markets helped further establish their brand identity and attract media attention, leading to features in lifestyle magazines and blogs, which boosted their profile and sales.

Creating a Destination

Some antique dealers have found success by creating a destination that offers more than just shopping. One entrepreneur transformed their antique booth into a mini museum, where customers could not only buy antiques but also learn about their historical significance. This approach turned their booth into a must-visit location within the antique mall, attracting customers interested in both the stories behind the items and the experience of connecting with history. This unique selling proposition helped them stand out in a crowded market, resulting in increased sales and customer engagement.

Collaborative Success

Success in the antique booth industry can also come from collaboration. A group of dealers with complementary offerings banded together to rent a larger space within an antique mall, creating a collective that offered a wide range of items, from furniture to collectibles. This diversity attracted a broader audience, and the collaborative marketing efforts expanded their reach.

The collective approach allowed them to share rental costs, collaborate on booth design and layout, and cross-promote each other's items, leading to increased sales and a strong presence in the market.

These success stories highlight the importance of innovation, niche marketing, online presence, and community engagement in the antique booth industry. They demonstrate that with passion, creativity, and a strategic approach, it is possible to turn a love for antiques into a thriving business.

Planning Your Antique Booth Business

Planning your antique booth business is a crucial step that lays the foundation for your future success. This phase involves a deep dive into market research, identifying a niche, setting clear objectives, and carefully crafting a strategy that aligns with your vision for the business. It's about more than just loving antiques; it's about transforming that passion into a viable enterprise that can grow and thrive in the competitive landscape of the antique industry.

The first step in planning your antique booth business is understanding the antique market as a whole. This broad market is composed of various niches, each with its own set of trends, customer bases, and pricing structures. Immersing yourself in the world of antiques, through attending shows, visiting malls, and engaging with other dealers, provides invaluable insights into how the market operates. It's essential to keep an eye on which items are in demand, which are declining in popularity, and what prices they command. This knowledge will guide you in making informed decisions about which items to stock in your booth.

Identifying your niche within the antique market is equally important. This could be anything from vintage clothing and jewelry to rustic farmhouse decor or mid-century modern furniture. Your niche should reflect not only your personal interests and expertise but also market demand. Focusing on a specific area allows you to build depth in your inventory and become a go-to expert for customers seeking items in that category. It also helps in differentiating your booth from competitors, giving you a unique selling proposition.

Conducting thorough market research is crucial for understanding your target audience and competitors. This involves identifying potential customers, understanding their preferences and buying habits, and analyzing what similar businesses are doing. Knowing your audience's demographics, such as age, income level, and interests, helps tailor your inventory and marketing strategies to appeal directly to them. Similarly, understanding your competition, including their pricing, marketing strategies, and customer service, can highlight opportunities for differentiation and growth.

Setting clear business objectives and goals is a pivotal part of the planning process. These should be specific, measurable, achievable, relevant, and time-bound (SMART). Goals might include reaching a certain level of sales within the first year, expanding your booth size or inventory range by a specific date, or establishing an online

presence to complement your physical booth. Setting goals gives you direction and allows you to measure your progress over time.

Developing a business plan brings all these elements together, outlining how you intend to achieve your objectives. This plan should cover your business structure, initial investment and financing, inventory sourcing strategies, pricing model, marketing and sales tactics, and long-term growth aspirations. It acts as a roadmap for starting and running your business, helping you stay focused and organized.

Preparing for the logistical aspects of running an antique booth business is essential. This includes selecting the right location for your booth, whether in a bustling antique mall, a weekend market, or a seasonal fair. Consider factors like foot traffic, the type of customers the location attracts, and the costs involved. Designing your booth to attract and retain customer interest, through effective display techniques and creating an inviting atmosphere, is also crucial.

Understanding the Antique Market

Understanding the antique market is crucial for anyone looking to venture into the antique booth business. This market is as diverse and layered as the items it encompasses, ranging from centuries-old heirlooms to mid-century modern pieces that have recently come to be considered vintage. A deep appreciation and knowledge of the items within your chosen niche, along with an understanding of market dynamics, are key to navigating this industry successfully.

At its core, the antique market is driven by the principles of supply and demand, but it's also heavily influenced by trends, historical significance, rarity, and the condition of items. One of the first steps in understanding this market is recognizing the different categories of items it includes, such as furniture, art, jewelry, books, and collectibles. Each category has its own set of collectors, price points, and marketplaces. For instance, the market for vintage fashion operates quite differently from that of antique furniture or collectible toys, with distinct cycles of demand and different platforms for sales.

Trends play a significant role in the antique market. Certain styles or periods come into vogue, driven by interior design trends, popular culture, or significant anniversaries of historical events, which can increase demand and prices for related items. Staying abreast of

these trends through research, attending antique shows, and engaging with online communities is essential for anticipating shifts in the market.

Historical significance and provenance can add considerable value to an item, attracting collectors who are willing to pay a premium for pieces with a documented history or connection to notable events or figures. Understanding how to research and verify the provenance of your items can not only increase their value but also your credibility as a dealer.

Rarity and condition are also critical factors in determining an item's value. Items that are rare, either due to limited production, age, or surviving in few numbers, can command higher prices. Similarly, items in excellent condition or with original features intact are typically more desirable than those that are damaged or have been significantly altered.

Another important aspect of understanding the antique market is recognizing the importance of authenticity and how it affects value. Learning how to authenticate items and differentiate between genuine antiques, reproductions, and fakes is a crucial skill that protects both your investment and your reputation.

The market for antiques is not static; it evolves with changing tastes, economic conditions, and the discovery of new items. Successful

dealers not only have a strong foundation in the history and identification of antiques but also remain flexible and responsive to market changes. They cultivate a network of contacts, including fellow dealers, collectors, and experts, to share knowledge and stay informed about market developments.

Pricing is another complex aspect of the antique market, requiring a balance between the intrinsic value of an item, its market demand, and the dealer's need for profitability. Pricing strategies often involve research into comparable items, an understanding of market conditions, and sometimes, intuition gained from experience.

The rise of digital platforms has transformed the antique market, expanding the reach of dealers and changing the way customers shop for antiques. While traditional venues like antique malls and shows remain important, online marketplaces, social media, and e-commerce sites have become vital tools for reaching a global audience. Adapting to these digital shifts while maintaining a presence in traditional marketplaces is now a key part of navigating the antique market.

Identifying Your Niche

Identifying your niche within the antique booth business is a critical step that shapes the direction of your venture, influences your branding, and determines your target market. A well-defined niche allows you to focus your buying and selling strategies, build expertise, and stand out in a crowded marketplace. Unlike a general approach that spreads efforts across a broad array of items, specializing in a specific area can lead to deeper connections with customers, more targeted marketing, and, ultimately, a more cohesive and attractive booth presentation.

The process of identifying your niche should start with your passions and interests. If you're naturally drawn to a certain period of history, style of furniture, type of artwork, or category of collectibles, this enthusiasm will not only make the business more enjoyable but also more authentic. Passion fuels the perseverance needed to hunt for treasures, research their origins, and share their stories with potential buyers. It also fosters a genuine connection with your customers, who are often drawn to dealers with a deep understanding and love for their niche.

Consider the market demand: While it's important to choose a niche that excites you, there needs to be a sufficient customer base interested in what you're selling. Conduct market research to gauge

interest levels in various categories. This can involve analyzing trends in interior design, attending antique shows and auctions to see what's selling, and engaging with online communities to understand current collecting trends. Balancing personal interest with market demand ensures that your passion is not only fulfilling but also profitable.

Understanding your competition: Explore antique malls, markets, and online platforms to see what others are selling and identify any gaps in the market. A niche with fewer competitors may offer more opportunities for your business to shine, but it's also important to ensure there's enough interest in that area to sustain sales. Sometimes, competition indicates a healthy market, but having a unique angle or specialization within a popular category can differentiate your booth from others.

Expertise in your chosen niche is vital: This doesn't mean you need to start as an expert, but you should be willing and eager to become one. Customers often look to antique dealers not just to buy items but to learn about them. The more knowledgeable you are about the history, authenticity, and value of the items in your niche, the more trust and credibility you'll build with your customers. This expertise can also guide your sourcing strategies, helping you to find undervalued items or recognize rare finds.

Consider the logistics of your niche: Some items, such as large pieces of furniture, require more space and resources to transport and display, while smaller collectibles can be easier to manage but may require more intricate knowledge to authenticate and price correctly. Your operational capabilities, from storage space to transportation, will play a role in determining the feasibility of focusing on certain types of antiques.

Market Research and Analysis

Market research and analysis are essential components in the planning phase of starting an antique booth business. This process involves gathering, analyzing, and interpreting information about the market, including potential customers, competitors, and overall industry trends. Effective market research can inform your business decisions, helping you to identify your niche, understand customer needs and preferences, and position your business for success in the competitive antique market.

Understanding Your Target Market

Identifying and understanding your target market is the cornerstone of effective market research. Your target market consists of the customers most likely to purchase from your antique booth. These can be collectors of specific types of antiques, interior designers looking for unique pieces, or casual buyers interested in vintage

decor. Researching your target market involves exploring factors such as their buying habits, preferences, the average spending budget, and which platforms they use to discover new items. Surveys, interviews, and observation at antique shows and malls can provide valuable insights into your potential customers' behaviors and preferences.

Analyzing Competitors

Competitor analysis gives you a clearer picture of the landscape in which you'll be operating. It involves identifying other antique dealers who cater to your target market, assessing the range of items they offer, their pricing strategies, and how they market their businesses. Visiting antique malls, browsing online marketplaces, and attending auctions can offer insights into what works (and what doesn't) in your specific niche of the antique market. Understanding your competitors helps you to differentiate your booth, highlighting what makes your collection unique and appealing to potential customers.

Evaluating Industry Trends

The antique market is influenced by broader trends in interior design, fashion, collectibles, and even social movements, such as the growing emphasis on sustainability. Keeping abreast of these trends can inform your buying decisions, marketing strategy, and business positioning. This could involve reading industry publications, following influencers and tastemakers in the antiques and vintage world, and participating in relevant online forums and social media groups. Recognizing and anticipating trends allows you to adapt your inventory and marketing strategies to meet evolving customer interests.

Pricing Strategy

An essential part of market research is understanding how to price your items. This involves not only knowing the value and provenance of your pieces but also understanding the price points at which your target market is willing to purchase. Pricing strategy can be influenced by various factors, including the rarity and condition of items, comparable sales, and the economic conditions affecting your target customers' spending power. Researching pricing involves looking at how similar items are priced in different venues, from local antique shops to online platforms, and considering the context of your specific market and customer base.

Utilizing Digital Tools

Digital tools and analytics can offer powerful insights into market trends and customer preferences. Social media platforms provide data on engagement and follower demographics, while online marketplaces can reveal popular items and pricing trends. Google Trends and keyword research tools can help identify what potential customers are searching for online, guiding your inventory and marketing efforts.

Iterative Process

Market research and analysis is an ongoing, iterative process. The antique market can change rapidly, with shifts in trends, customer preferences, and the competitive landscape. Continuously gathering and analyzing data allows you to adapt your business strategy to these changes, ensuring your antique booth remains relevant and appealing to your target market.

Setting Business Objectives and Goals

Setting clear business objectives and goals is pivotal for the success and direction of your antique booth business. Objectives provide a roadmap for decision-making and help prioritize actions, while goals offer measurable milestones to gauge progress. These elements are crucial for maintaining focus, motivating you and any team members, and providing a framework for evaluating the performance of your business.

The process of setting objectives and goals starts with defining what you want to achieve in both the short term and long term. These ambitions should be aligned with your passions, strengths, and the opportunities identified through market research. It's important to ensure that your objectives are SMART: Specific, Measurable, Achievable, Relevant, and Time-bound. This framework helps in creating clear, actionable plans.

Specific

Your objectives should be clear and specific to avoid any ambiguity about what you're trying to achieve. For example, rather than setting a goal to "increase sales," a specific objective would be to "increase

sales of vintage jewelry by 20% within the next 12 months." This specificity guides which actions are necessary to achieve the goal.

Measurable

Objectives need to be measurable so that you can track your progress and know when you've achieved your goal. This could involve quantifiable targets like revenue figures, customer numbers, or inventory turnover rates. For instance, setting a goal to "acquire 30 new customers each month" provides a clear metric for measurement.

Achievable

While it's important to be ambitious, your goals also need to be realistic and attainable within the resources and time you have. This means considering the financial, logistical, and time constraints you face and setting goals that are challenging yet within reach. Achievability ensures that objectives are motivating rather than disheartening.

Relevant

Each goal should contribute to the broader vision of your business and be relevant to the direction you want your antique booth to take. For example, if a key aim of your business is to become a leading

dealer in Art Deco furniture, your objectives should focus on actions that support this vision, such as expanding your Art Deco inventory or establishing expertise in this area.

Time-bound

Setting deadlines is crucial for maintaining momentum and focus. A time-bound goal creates a sense of urgency and helps prioritize actions. For example, setting a goal to "launch an online store for your antique booth by the end of the quarter" gives a clear timeframe for achieving this milestone.

Beyond these SMART criteria, it's essential to consider the broader impacts of your goals. Think about how achieving these objectives will affect different aspects of your business, from financial health to customer satisfaction and brand reputation. Additionally, setting both short-term goals (like monthly sales targets) and long-term goals (such as establishing a prominent brand within five years) ensures that you're working towards immediate improvements while keeping an eye on the future growth and direction of your business.

Regularly reviewing and adjusting your objectives and goals is also important. The antique market can change, new opportunities can arise, and challenges can emerge. By staying flexible and responsive to these dynamics, you can refine your goals to better align with the evolving landscape of your business and the wider antique market.

Legal and Financial Considerations

When embarking on the journey of opening an antique booth business, it's crucial to navigate the legal and financial considerations with care and diligence. These foundational aspects not only ensure your business operates within the law but also lay the groundwork for its financial health and sustainability.

Starting with legal considerations, the first step is choosing the appropriate business structure. This decision affects everything from your liability and taxes to your ability to raise funds. Many antique booth owners start as sole proprietors, a straightforward option with fewer regulatory hurdles. However, forming a limited liability company (LLC) can offer protection by separating personal assets from business liabilities. Each structure has its advantages and tax implications, so it's advisable to consult with a legal expert or accountant to determine the best fit for your business goals and risk tolerance.

Obtaining the necessary licenses and permits is another vital step. Requirements vary by location but often include a business license, a sales tax permit, and possibly a specific antique dealer license. These licenses ensure you're authorized to operate your business and sell goods within your jurisdiction. Additionally, staying informed about import and export laws, as well as regulations surrounding the sale of certain older items, is crucial to avoid legal pitfalls.

Insurance is an often overlooked but essential consideration. Antique items can be rare, valuable, and irreplaceable, making insurance critical to protect against loss, damage, or theft. A comprehensive policy that covers your inventory, liability, and possibly even business interruption, can safeguard your financial investment. Consulting with an insurance agent who understands the unique needs of antique dealers is advisable to get coverage that aligns with your business activities and risk exposure.

Turning to financial considerations, setting up a business bank account is fundamental. This not only simplifies tax preparation and accounting but also reinforces the legal distinction between your personal and business finances, which is especially important for LLCs and corporations. Effective bookkeeping and accounting practices are vital for tracking expenses, managing inventory costs, and analyzing profitability. Many antique booth owners opt for

accounting software or hire professionals to keep financial records accurate and up-to-date.

Understanding your tax obligations is another critical aspect. This includes not only income taxes but also sales taxes on items sold. The complexity of tax requirements can vary significantly depending on your business structure, location, and the nature of your transactions. Regularly consulting with a tax professional can help navigate these complexities, ensure compliance, and potentially identify tax-saving opportunities.

Financial planning and forecasting are indispensable for the long-term success of your antique booth business. This involves creating budgets, setting financial goals, and projecting future income and expenses. Financial planning helps in making informed decisions, such as when to expand your inventory, invest in marketing, or save for slower periods. It also prepares you for securing loans or attracting investors by providing a clear picture of your business's financial health and growth potential.

Choosing the Right Business Structure

Choosing the right business structure is a pivotal decision when starting an antique booth business, as it impacts your legal liabilities, tax obligations, and the overall management of your enterprise. The structure you select influences how much you pay in taxes, the level and type of regulatory paperwork you need to file, your ability to raise money, and your personal liability in the business.

Sole Proprietorship

For many starting out in the antique booth business, a sole proprietorship is the most straightforward option. This structure is easy to establish and doesn't require registering with the state, except for obtaining the necessary business licenses and permits. As a sole proprietor, you have complete control over your business decisions, but you also bear full personal liability for any debts or legal actions against your business. This means that personal assets, such as your home or savings, could be at risk if your business faces a lawsuit or can't pay its debts. Tax-wise, profits and losses from your business are reported on your personal tax return, simplifying the process but also mingling business and personal finances.

Partnership

If you're considering starting your antique booth with one or more partners, a partnership could be the right choice. Partnerships come in various forms, including general partnerships, limited partnerships (LPs), and limited liability partnerships (LLPs), each offering different levels of liability protection and involvement in the business. Like sole proprietorships, general partnerships do not offer personal liability protection, meaning all partners are responsible for the debts and legal obligations of the business. However, LPs and LLPs allow for limited liability for some partners, protecting personal assets. Partnerships require a clear agreement on the division of profits, losses, and responsibilities, and profits are reported on each partner's tax return, similar to sole proprietorships.

Limited Liability Company (LLC)

A Limited Liability Company (LLC) combines the liability protection of a corporation with the tax efficiencies and operational flexibility of a partnership. Owners of an LLC, known as members, are not personally liable for the debts or liabilities of the business, offering significant protection for personal assets. LLCs offer flexibility in taxation, allowing members to choose to be taxed as a sole proprietorship, partnership, or corporation, depending on what's most advantageous. This structure is more complex to set up than a

sole proprietorship or partnership and may have higher initial costs, but it offers greater protection and flexibility.

Corporation

For those planning to scale their antique booth business significantly, a corporation might be considered. Corporations offer the strongest protection from personal liability, but they are more costly to establish and involve more complex regulatory and tax requirements. Corporations can raise funds through the sale of stock and are taxed as separate legal entities, which can lead to double taxation—once at the corporate level and again on the individual level when dividends are paid to shareholders. However, the corporate structure is often more attractive to investors and can be beneficial for businesses planning significant growth or expansion.

S Corporation

An S Corporation is a special type of corporation created through an IRS tax election. It allows profits, and some losses, to be passed directly to owners' personal income without being subject to corporate tax rates. Not all states tax S corporations equally, but many recognize them similarly to the federal government and tax the shareholders accordingly. S Corporations combine the liability protection of a corporation with some tax benefits of a smaller

entity, though they come with restrictions on the number and type of shareholders.

Making the Decision

When deciding on a business structure for your antique booth business, consider factors such as the level of liability protection you need, the tax implications, the potential for raising capital, and the complexity of management and operations you're prepared to handle. Consulting with legal and tax professionals can provide valuable insights tailored to your specific situation, helping you make an informed decision that aligns with your business goals and personal risk tolerance.

Obtaining Necessary Licenses and Permits

Navigating the maze of required licenses and permits is a crucial step in establishing your antique booth business on solid legal footing. The specific requirements can vary widely depending on your location, the nature of the items you sell, and how you choose to sell them. Understanding and complying with these regulations from the outset not only avoids legal pitfalls but also builds trust with customers and partners.

General Business License

Virtually all businesses, including antique booths, need a general business license to operate legally in their city or county. This license serves as your formal registration with the local government and is fundamental regardless of your business structure or size. Obtaining this license typically involves filling out an application and paying a fee. The application process may require basic information about your business, such as its name, address, and the nature of its operations.

Seller's Permit and Sales Tax License

If you're selling goods, as is the case with an antique booth, you're likely required to collect sales tax on transactions. This necessitates obtaining a seller's permit or a sales tax license. This permit not only authorizes you to collect sales tax on behalf of the government but also to report and pay those taxes to the state. Requirements vary by state, and in some cases, by locality, so it's crucial to check with your state's Department of Revenue or equivalent body to understand your obligations.

Special Antiques and Collectibles Considerations

Depending on what you sell, there may be additional regulatory considerations. For example, selling items that contain materials from endangered species (such as ivory) can be subject to state, federal, and even international regulations. Similarly, the sale of antique firearms, alcohol-related collectibles, or items of significant cultural heritage might require specialized permits or fall under strict regulatory frameworks. Being well-informed about the specific regulations governing the sale of your items is essential to operate legally.

Home-Based Business Permits

If you're operating your antique booth business out of your home, or if your home serves as the primary base for your online sales, you might need a home-based business permit. Local zoning laws often regulate home-based businesses to ensure they don't disrupt residential areas. Restrictions can vary widely, so it's important to check with your local zoning board to ensure your business complies with any restrictions or requirements, such as limitations on signage or customer traffic.

Event or Market Specific Permits

Participating in antique shows, flea markets, or pop-up events often requires additional permits or registrations. Event organizers typically provide guidance on any required documentation, but it's your responsibility to ensure you have the proper permits to sell at these venues. These permits may be event-specific or require separate applications with local or state authorities.

Keeping Up-to-Date

It's important to note that licensing and permit requirements can change, and renewal is often required on an annual or biennial basis. Establishing a system for tracking renewal deadlines ensures that your business remains in compliance and avoids unnecessary fines or disruptions.

Professional Assistance

Given the complexity and variability of licensing and permit requirements, consulting with a professional, such as a business attorney or a local small business development center, can be invaluable. These experts can provide tailored advice based on your specific business model, location, and the types of items you plan to sell, ensuring that you have all necessary licenses and permits to operate legally and successfully.

Insurance for Your Antique Booth Business

Insuring your antique booth business is a critical step in safeguarding your investment and ensuring the longevity of your venture. The unique nature of dealing in antiques—items that are often irreplaceable and carry significant value—requires a tailored approach to insurance. Understanding the different types of insurance available and determining the right coverage for your business can protect against financial losses due to damage, theft, liability claims, and other unforeseen events.

Business Property Insurance

Business property insurance is fundamental for any retail operation, including antique booths. This type of insurance covers the physical assets of your business, such as inventory, display cases, signage, and other equipment. For an antique dealer, where the inventory can include rare and valuable items, ensuring that your policy adequately covers the actual value of these items is crucial. It's important to work with your insurer to understand how they value items and what proof they require in the event of a claim, as antiques often don't have straightforward replacement costs like new goods.

General Liability Insurance

General liability insurance protects your business from financial loss should you be liable for property damage or personal injury caused by your products, services, or operations. In the context of an antique booth, this could cover incidents where a customer is injured by a piece of furniture or when an item you sell causes damage in a customer's home. General liability insurance can also help cover the costs associated with legal defense and settlements.

Product Liability Insurance

Given that antiques and collectibles can sometimes pose unexpected risks to buyers (due to age, materials, or construction), product liability insurance is worth considering. This insurance can protect against claims related to items you sell that cause injury or damage. For example, if a piece of antique electrical equipment you sold causes a fire, product liability insurance could cover the damages and legal costs.

Professional Liability Insurance

If you offer appraisals or authentication services as part of your antique booth business, professional liability insurance, also known as errors and omissions insurance, can protect against claims of

negligence, misrepresentation, or inaccurate advice. This type of insurance is particularly relevant if your guidance or valuation directly influences a customer's buying or selling decisions.

Business Interruption Insurance

Business interruption insurance can provide financial support if your operation is temporarily halted due to a covered event, such as a fire or natural disaster. For an antique booth located within a larger marketplace or mall, this coverage can help compensate for lost income and cover ongoing expenses until you can reopen. Given the potential for significant financial impact from interruptions, especially in locations susceptible to natural disasters, this insurance is an important consideration.

Specialized Antique Insurance

Some insurance providers offer policies specifically tailored to the needs of antique dealers. These specialized policies can provide more appropriate coverage for the unique aspects of dealing in antiques, including items on consignment, items in transit between shows or auctions, and fluctuating inventory values. Working with an insurer familiar with the antique industry can ensure that your coverage aligns with your specific business risks and needs.

Regularly Reviewing Your Coverage

As your antique booth business grows and evolves, so too will your insurance needs. Regularly reviewing your policy with your insurance provider ensures that your coverage remains adequate, especially as you acquire new items, expand your services, or change your operational setup. Keeping an up-to-date inventory list, with detailed descriptions and appraised values of your items, is also crucial for managing your insurance effectively.

Setting Up Your Business Bank Account and Accounting System

Setting up a business bank account and establishing a solid accounting system are crucial steps in managing the financial health of your antique booth business. These foundational elements not only help in organizing finances but also play a critical role in the overall success and scalability of your venture. Here's a detailed exploration into why these components are important and how to effectively implement them.

Business Bank Account

A dedicated business bank account separates your personal finances from your business operations, a practice that is essential for legal, tax, and organizational reasons. This separation simplifies bookkeeping, enhances professionalism, and provides clarity on the business's financial health. When choosing a bank, consider factors like fees, accessibility, customer service, and any value-added services that might be beneficial for your business.

1. Legal and Tax Clarity: Having a separate account simplifies tax preparation by clearly delineating personal and business transactions. It also supports the legal distinction between your personal and business assets, especially important if your business structure offers liability protection, such as an LLC.

2. Professionalism: Paying suppliers and receiving payments through a business account enhances your professionalism and credibility in the eyes of customers, vendors, and financial institutions.

3. Financial Management: A dedicated account makes it easier to track income, manage expenses, and analyze financial performance, providing vital insights for strategic decision-making.

Accounting System

An efficient accounting system is indispensable for tracking your business's financial activities, complying with tax regulations, and

making informed business decisions. Today's options range from simple spreadsheet-based systems to sophisticated accounting software tailored to small businesses.

1. Record Keeping: Accurate and timely record-keeping is essential for understanding your business's financial status, preparing financial statements, and filing taxes. It involves documenting sales, purchases, expenses, and inventory changes.

2. Compliance: A robust accounting system helps ensure compliance with tax laws and financial reporting standards. It can automate calculations, tax filings, and generate reports needed for legal and tax purposes.

3. Financial Analysis and Planning: The insights gained from your accounting system are vital for budgeting, forecasting, and planning. Analyzing trends, profitability, and cash flow helps in making strategic business decisions.

Implementing Your Accounting System

Choose the Right Tools: Select accounting software that fits your business size, complexity, and budget. Many modern software solutions are designed with small business owners in mind, offering user-friendly interfaces, cloud-based access, and integration with banking systems.

Understand Basic Accounting Principles: Familiarize yourself with basic accounting concepts such as double-entry bookkeeping, accounts payable/receivable, and the difference between cash and accrual accounting methods. This knowledge will help you set up your system correctly and interpret financial data accurately.

Regular Reconciliation: Regularly reconcile your business bank account with your accounting records to ensure accuracy. This process helps identify discrepancies early and maintain accurate financial records.

Professional Assistance: Consider hiring a professional accountant or bookkeeper, especially as your business grows or if accounting is not your strength. They can offer invaluable advice on financial management, tax planning, and compliance, ensuring your accounting system serves your business effectively.

Stay Informed and Compliant: Keep abreast of tax laws, financial regulations, and accounting best practices relevant to your business. Attending workshops, subscribing to financial newsletters, and participating in business networks can provide valuable insights and updates.

Setting up a business bank account and a comprehensive accounting system are foundational steps toward establishing a successful antique booth business. These measures not only ensure financial

organization and compliance but also equip you with the tools necessary for informed decision-making and strategic financial planning.

Understanding Tax Obligations

Understanding your tax obligations is crucial for the success and legality of your antique booth business. Taxation can be complex, with obligations varying based on your business structure, location, and the nature of your transactions. Being well-informed about these responsibilities helps in planning, compliance, and potentially optimizing your tax situation.

Here's a detailed look into key tax considerations for antique booth owners.

Sales Tax

One of the primary tax obligations for antique booth owners involves collecting and remitting sales tax on transactions. The applicability and rate of sales tax can vary significantly depending on the state and even local jurisdiction in which you operate.

Registration: Before you start selling, you typically need to register for a sales tax permit with your state's department of revenue. This registration allows you to legally collect sales tax from customers.

Collection: With a sales tax permit, you're responsible for adding the appropriate sales tax to each sale, based on the item's sale price and the applicable tax rate. It's crucial to stay updated on the tax rates in your sales locations, as they can change.

Remittance: After collecting sales tax, you must periodically remit it to the state. The frequency of these payments (monthly, quarterly, and annually) often depends on the volume of your sales.

Income Tax

As a business owner, you're also subject to income tax on the profits your antique booth generates. How you report this income and the rate at which it's taxed depend on your business structure.

Sole Proprietorship and Partnerships: Profits (or losses) from the business are passed through to your personal income tax return, where they're taxed at your personal income tax rate.

LLC: Depending on the election made by the LLC, the taxation can mirror that of sole proprietorships, partnerships, or S corporations, with income passing through to owners' personal tax returns.

Corporations (C Corp): The Corporation pays income tax at the corporate rate, and dividends paid to shareholders are taxed again at the individual's tax rate.

Self-Employment Taxes

If your business is structured as a sole proprietorship, partnership, or LLC (and you haven't elected to be taxed as a corporation), you will also need to pay self-employment taxes. This tax covers your contribution to Social Security and Medicare.

Quarterly Estimated Taxes

If you expect to owe tax of $1,000 or more when your return is filed, the IRS requires you to make estimated tax payments throughout the year. This is often the case for successful antique booth businesses, where sales and income can result in a significant tax bill at the end of the year. Estimated taxes are paid quarterly and are based on the income earned and the associated taxes calculated for that period.

Record-Keeping and Documentation

Maintaining thorough records is vital for managing your tax obligations. This includes keeping detailed records of sales, purchases, expenses, and inventory changes. Proper documentation not only supports your tax filings but can also be invaluable in the event of an audit.

State and Local Taxes

In addition to federal taxes, you must also be aware of state and local tax obligations. These can include state income taxes, property taxes (if you own your business location), and other local taxes. Requirements vary widely by location, so it's essential to research the obligations specific to where you operate.

Professional Advice

Given the complexities of tax law and the potential consequences of non-compliance, consulting with a tax professional is advisable. A qualified accountant or tax advisor can provide guidance tailored to your specific situation, helping you navigate tax obligations efficiently and effectively. They can also offer strategies for tax optimization, ensuring you're not paying more than necessary while remaining compliant with tax laws.

Understanding and managing your tax obligations is a fundamental aspect of running a successful antique booth business. By staying informed, maintaining accurate records, and seeking professional advice, you can ensure compliance, avoid penalties, and potentially enhance your business's financial health.

Sourcing Antique Items

Sourcing antique items is both an art and a science, requiring a blend of knowledge, networking, and negotiation skills. For antique booth owners, the ability to find unique, high-quality items at the right price is crucial to the success and identity of their business. The process involves a constant search for hidden gems that will captivate customers and stand out in the competitive antique market.

The journey often starts with a deep understanding of what you're looking for, which is informed by your niche, market trends, and customer preferences. This knowledge guides where you look for items and helps you evaluate their potential value and appeal. Experienced dealers develop an eye for spotting undervalued items or recognizing the potential in pieces that others might overlook.

Estate sales, auctions, and flea markets are traditional hunting grounds for sourcing antiques. Estate sales, in particular, can be a treasure trove, offering items with history and character often coming directly from homes where they've been cherished for years. Auctions, while potentially competitive, can also be an excellent source for rare or high-value items, especially when you're well-informed about what you're bidding on. Flea markets offer the thrill of the hunt, with the possibility of finding unexpected gems among the stalls.

Antique shows and dealer markets are another valuable source, bringing together a wide range of sellers and items under one roof. These venues offer the advantage of variety and the opportunity to network with other dealers and experts. Building relationships in these environments can be beneficial, as fellow dealers might tip you off about upcoming sales or offer items directly to you.

Online marketplaces and platforms have dramatically expanded the possibilities for sourcing antiques. Websites like eBay, Etsy, and Ruby Lane, along with social media platforms, provide access to a global inventory. Online sourcing requires a different set of skills, including the ability to assess items based on photos and descriptions and understanding the nuances of online bidding and buying. Despite these challenges, the internet can be a source for both common and rare items, often at competitive prices.

Networking with personal contacts, including collectors, fellow dealers, and even individuals looking to downsize or sell personal collections, can lead to unique sourcing opportunities. Establishing a reputation as a fair and knowledgeable buyer can encourage people to offer you first dibs on items or collections before they reach the broader market.

Consignment and pickers are other avenues for sourcing inventory. Some dealers develop relationships with pickers, individuals who specialize in finding and selling antiques, to source items on their behalf. Consignment, where you sell items owned by others in your booth for a fee or commission, can also provide a steady stream of inventory without the upfront cost of purchasing items outright.

The condition and authenticity of items are paramount in sourcing. Developing skills in identifying repairs, reproductions, and forgeries is crucial, as is understanding how condition affects value. This might involve learning specific markers of authenticity for different types of items or becoming proficient in using tools and tests to verify materials and age.

Negotiation is an integral part of sourcing, whether you're dealing with auction houses, private sellers, or flea market vendors. Building a rapport, understanding the seller's motivations, and being willing to walk away are all strategies that can help you secure items at the right price.

Tips for Buying Antiques

Buying antiques is both an art and a science, requiring a blend of knowledge, intuition, and strategy. Whether you're stocking an antique booth or enriching a personal collection, mastering the nuances of purchasing antiques can lead to rewarding finds and worthwhile investments. Here are some essential tips to enhance your buying strategy and ensure you make informed decisions when adding to your collection.

Educate Yourself: Knowledge is power in the world of antiques. Familiarize yourself with the periods, styles, and characteristics of the items you're interested in. Understanding historical contexts, materials, and manufacturing techniques can help you assess an item's authenticity and value. Resources like books, online forums, and educational seminars can be invaluable.

Inspect Items Thoroughly: Condition plays a crucial role in determining an antique's value. Inspect items carefully for signs of wear, damage, or restoration. Look for indications of authenticity, such as maker's marks, signatures, or provenance. Use tools like magnifying glasses or UV lights if necessary to examine items closely. Be wary of reproductions and fakes, which are common in the market.

Negotiate Wisely: Negotiation is a standard practice in the antique world. However, it's important to do so respectfully and knowledgeably. Before negotiating, research the item's market value to understand its worth. Always be polite and express genuine interest in the piece. Sellers are more likely to offer a better price to buyers who appreciate the value of their items.

Establish a Network: Building relationships with other dealers, collectors, and experts can open doors to private sales, insider information, and better deals. Attend antique shows, auctions, and events to connect with the antique community. Networking can also provide opportunities for learning and mentorship.

Focus on Quality over Quantity: It's better to have a smaller collection of high-quality pieces than a large collection of mediocre items. Quality pieces are more likely to appreciate in value and attract the interest of discerning buyers. Look for items in the best condition possible and with a clear historical significance or aesthetic appeal.

Stay Updated on Trends: The antique market is influenced by changing trends and tastes. Stay informed about what's currently in demand, as well as emerging trends. This knowledge can guide your buying decisions, helping you to invest in pieces that are likely to increase in value or appeal to contemporary buyers.

Diversify Your Sources: Don't rely solely on one source for buying antiques. Explore various venues such as estate sales, auctions, flea markets, online marketplaces, and direct sales from collectors. Diversifying your sources can help you find the best deals and uncover hidden gems.

Invest in What You Love: While it's important to consider market trends and investment potential, buying antiques you're passionate about makes the process more enjoyable and fulfilling. Your enthusiasm for the pieces you select will resonate with customers and fellow collectors.

Document Your Purchases: Keep detailed records of your acquisitions, including descriptions, conditions, purchase prices, and any provenance information. This documentation is crucial for insurance purposes, future sales, and maintaining an organized inventory.

Consider Restoration Costs: When buying items in need of restoration, carefully consider the costs and potential value increase post-restoration. Some items may be worth the investment, while others may not yield a significant return. Consulting with restoration experts can provide clarity on these potential expenses.

Verifying Authenticity and Value

Verifying the authenticity and value of antiques is a crucial aspect of dealing in the antique market, where the difference between a genuine piece and a reproduction can significantly impact an item's worth. Mastery in this area not only protects your investment but also builds your reputation as a knowledgeable and trustworthy dealer.

Here are key strategies to help you accurately assess both the authenticity and value of antiques:

Research and Education: Continuous education is paramount in the antiques world. Familiarize yourself with the hallmarks of authenticity for the specific types of items you deal with, whether they're furniture, artworks, jewelry, or collectibles. Understanding historical contexts, manufacturing techniques, and stylistic features of different periods and makers can aid significantly in authenticity assessment.

Examine the Provenance: Provenance, or the history of ownership, can provide valuable clues about an item's authenticity and history. Authentic pieces often come with documentation or a traceable history that can verify their origin and age. Provenance can also enhance an item's value, especially if it has a significant or interesting history.

Look for Age Indicators: Genuine antiques show signs of age and wear in a way that reproductions cannot accurately replicate. For furniture, look for uneven fading, wear patterns, and natural patination. In artworks, craquelure (fine cracking patterns) can indicate age, though it's not a foolproof indicator. With porcelain or ceramics, look for signs of wear on the bottom or any marks indicating the manufacturer and age.

Use Scientific Methods: In some cases, scientific methods can be employed to verify the age and authenticity of an item. Techniques like radiocarbon dating, spectroscopy, and thermoluminescence can determine the age of materials accurately. These methods can be costly and require expert execution, so they're typically reserved for highly valuable items.

Consult Experts: When in doubt, consult with experts. Specialized dealers, appraisers, and conservators can offer invaluable insights based on their experience and expertise. Building a network of reliable experts you can call upon for advice is an invaluable resource for any antique dealer.

Understand Marks and Signatures: Many antique items, from silverware to ceramics and paintings, feature maker's marks, hallmarks, or signatures that can verify their origin. Familiarize yourself with these marks and their meanings. There are numerous

reference books and online databases dedicated to deciphering these identifiers.

Evaluate Restoration and Repairs: Understanding the impact of restorations and repairs on an item's value is crucial. While well-executed restorations can preserve or enhance value, poor restoration work can diminish it. Assess the quality of any restoration work and consider its impact on the item's overall authenticity and value.

Market Comparison: Comparing similar items in the market can help establish value. Auction results, dealer prices, and online marketplace listings provide a benchmark for what similar items are selling for, though it's important to account for condition, provenance, and market trends in these comparisons.

Assess Rarity and Demand: The value of an antique is greatly influenced by its rarity and the current demand in the market. Items that are rare, have a high demand, or both tend to be more valuable. Market research and staying informed about current trends can help you gauge these factors accurately.

Document Your Findings: Keep detailed records of your assessments, including notes on an item's condition, provenance, marks or signatures, and any expert consultations. This

documentation not only aids in establishing value but can also be important for insurance, resale, and maintaining the item's history.

Verifying the authenticity and value of antiques requires a multifaceted approach, combining thorough research, expert knowledge, and practical experience. By honing these skills, you can make informed decisions, protect your investments, and enhance your credibility in the antique market.

Building Relationships with Suppliers

Building strong relationships with suppliers is a cornerstone of success in the antique booth business. These relationships can provide access to unique and high-quality items, favorable purchase terms, and valuable market insights. Establishing and nurturing connections with a diverse network of suppliers—from individual collectors to auction houses and estate sale companies—requires a thoughtful approach that emphasizes trust, mutual respect, and long-term collaboration.

Here are strategies for building and maintaining effective relationships with suppliers in the antique industry:

Regular Communication: Maintaining regular contact with your suppliers is key to fostering strong relationships. This doesn't mean only reaching out when you need something; it also involves checking in periodically, sharing market insights, and expressing appreciation for past transactions. Effective communication helps keep you top of mind and can lead to suppliers thinking of you first when they come across items that fit your niche.

Honesty and Integrity: Trust is the foundation of any strong business relationship. Be transparent about your needs, expectations, and budget constraints. Honesty in negotiations, prompt payments, and integrity in dealing with disputes or returns build trust and credibility, making suppliers more likely to go the extra mile for you in the future.

Mutual Respect: Respect your suppliers' expertise and time. Recognize the effort that goes into sourcing, restoring, and authenticating antiques. When discussing prices or terms, be fair and considerate of their need to make a profit as well. Respectful negotiations and dealings ensure a positive atmosphere and foster goodwill.

Loyalty: While it's important to diversify your sources, showing loyalty to your key suppliers can be beneficial. Suppliers are more likely to offer you better deals, first picks on new items, and flexible payment terms if they see you as a loyal and reliable customer.

However, loyalty doesn't mean accepting unfavorable terms; it's about prioritizing relationships with suppliers who offer value and treat you well.

Personal Connections: Building personal connections with your suppliers can transform purely transactional relationships into valuable partnerships. Take the time to learn about them—their interests, challenges, and goals. Attending industry events, antique shows, and social gatherings can provide opportunities to strengthen these personal connections.

Offer Feedback and Appreciation: Provide constructive feedback about the items you purchase and express appreciation when suppliers meet or exceed your expectations. Recognizing their efforts and contribution to your business's success encourages a positive, ongoing relationship. Small gestures, like thank-you notes or mentioning them in your marketing materials (with their permission), can go a long way.

Collaborate on Projects: Look for opportunities to collaborate with suppliers on projects or events that can benefit both parties, such as co-hosting an antique appraisal event or participating in a joint marketing campaign. Collaboration can deepen the relationship and open new avenues for business.

Understand Their Business: The more you understand about your suppliers' operations, challenges, and goals, the better you can align your requests and interactions with their capabilities and expectations. This understanding fosters empathy and can help you navigate negotiations and collaborations more effectively.

Flexibility and Patience: The antique market can be unpredictable, with the availability of specific items fluctuating based on numerous factors. Being flexible with your demands and patient with supply fluctuations shows understanding of the industry's nature and builds resilience into your supplier relationships.

Networking: Expand your supplier network through referrals and by being active in the antique community. Attending auctions, estate sales, and industry conferences can introduce you to new suppliers and opportunities. Networking not only broadens your source of inventory but also enhances your reputation as a serious and engaged dealer.

Building and maintaining strong relationships with suppliers is an ongoing process that can significantly impact the success of your antique booth business. By approaching these relationships with a focus on mutual benefit, respect, and collaboration, you can secure a steady supply of desirable antiques and position your business for long-term success.

Setting Up Your Antique Booth

Setting up your antique booth involves much more than just arranging items for sale; it's about creating an engaging, cohesive environment that draws customers in and encourages them to explore—and ultimately purchase—your curated collection of antiques. The layout, design, and overall presentation of your booth play critical roles in attracting and retaining customer interest, making the setup process both an art and a strategic endeavor.

The first step in setting up your booth is selecting the right location. This decision can significantly impact foot traffic and sales. If you're setting up in an antique mall or at a fair, try to secure a spot near the entrance or along the main walkway where your booth is more likely to catch the eyes of passersby. Corner booths or those near cafes or restrooms where people may linger can also be advantageous.

Once you have your location, focus on creating a theme or story for your booth. This doesn't mean every item must be from the same era or style, but there should be a cohesive feel or narrative that ties your collection together. This could be a focus on a specific period, such as Victorian or Mid-Century Modern, a type of item like vintage jewelry or nautical antiques, or even a color scheme. A clear theme

can help your booth stand out and attract customers who are interested in those particular styles or items.

The design of your booth should facilitate a pleasant browsing experience. Ensure there's a clear path for customers to move through without feeling cramped. Use shelving, tables, and hanging systems to display items at different heights, making effective use of space and creating a dynamic visual field. Lighting is crucial in showcasing your items properly, especially in indoor settings or darker corners. Spotlights or small lamps can highlight specific pieces and add warmth to your booth.

Your booth's signage is another important consideration. It should be clear, professional, and reflective of your brand, whether that's elegant, quirky, or minimalist. Price tags should also be clear and consistent; consider using tags that provide a bit of information about the item's history or significance, which can add value in the eyes of collectors.

In setting up your booth, the arrangement of items is key. Group similar items together to create areas of focus, but avoid cluttering. Give standout pieces space to shine. Mixing in some modern or reproduction pieces, if they fit with your theme, can add variety and appeal to a broader range of customers. However, be transparent about the nature of these items to maintain trust and credibility.

Interactivity can also enhance the customer experience. If feasible, set up a small area where customers can try on vintage jewelry or examine items up close with a magnifier. Engaging the senses and encouraging customers to interact with your items can make the shopping experience more memorable and personal.

Finally, your booth should reflect your passion and knowledge of antiques. Be prepared to share stories about the items, offering insights into their history, provenance, or what makes them unique. This not only enriches the customer's experience but also establishes your expertise and credibility.

Selecting the Right Location

Selecting the right location for your antique booth is a pivotal decision that can significantly influence your business's visibility, foot traffic, and overall success. The ideal location not only aligns with your target market's preferences but also enhances the appeal of your collection, drawing in customers and encouraging sales.

Here's an in-depth look at considerations for choosing the most advantageous spot for your antique booth, whether you're setting up in an antique mall, at a fair, or within a flea market:

Understand Your Target Market

The first step in selecting the right location is understanding who your target customers are and where they are likely to shop. Different locations attract different demographics. For instance, upscale antique malls may attract customers looking for high-end, rare pieces, while community flea markets may draw in those searching for bargains or eclectic finds. Consider the type of antiques you sell and match your location to the buying habits and preferences of your intended audience.

Assess Foot Traffic

High foot traffic is crucial for the success of any retail endeavor, including antique booths. Locations that naturally attract a lot of visitors—such as entrances, near cafes, or along main aisles—can increase the number of potential customers who see your booth. Spend time observing the flow of traffic at various times and days to identify spots that consistently draw crowds.

Visibility and Accessibility

Your booth's visibility from various points within the venue can greatly affect customer engagement. Being easily seen from main walkways or adjacent to popular booths can draw more visitors. Accessibility is also key; ensure your booth is easy to navigate to and around, without obstacles that could deter potential customers.

Booth Size and Layout

Consider the size and layout of the available spaces. You need enough room to display your items attractively without overcrowding, but too much space might make your booth look sparse or require you to acquire more inventory than you're ready for. The shape of the booth, whether square, rectangular, or another configuration, can also impact how you arrange your items and create flow within your space.

Complementary Neighbors

Being situated near booths that sell complementary items can be beneficial. For example, if you specialize in vintage jewelry, being near clothing or accessory dealers can attract customers interested in fashion from specific eras. However, being too close to direct competitors may not be ideal unless you're confident in your collection's unique appeal or value proposition.

Lease Terms and Costs

Understand the lease terms and costs associated with different locations within a venue. Prime spots often come at a premium, but the increased expense may be justified by higher sales volume. Consider your budget and how much you're willing to invest in location as part of your overall business strategy.

Test Different Locations

If possible, try out different locations within a venue over time to see which spots yield the best results. What works for one dealer may not work for another, depending on the type of antiques sold and the dealer's sales style. Experimenting with location can provide valuable insights into customer behavior and preferences.

Negotiate Flexibility

When negotiating your spot, see if there's flexibility to move to a different location if the one you choose initially doesn't meet your expectations. Some venues may be open to periodic relocations within their space, offering you the chance to find the optimal spot for your booth over time.

Selecting the right location for your antique booth involves a combination of strategic thinking, market understanding, and sometimes, a bit of trial and error. By carefully considering these factors, you can greatly enhance your booth's potential for success, attracting more customers and boosting sales in the competitive world of antiques.

Booth Design and Layout Tips

The design and layout of your antique booth play pivotal roles in attracting customers and encouraging sales. A well-thought-out booth not only showcases your items in the best light but also creates an inviting atmosphere that encourages visitors to linger and explore. Here's a guide to designing an effective and engaging booth layout, tailored to the unique world of antiques.

Create a Focal Point: Every booth should have a focal point or a standout piece that draws attention. This could be a particularly rare item, an eye-catching piece of furniture, or a vibrant artwork. Place your focal point strategically so it's visible from the aisle or entrance, drawing visitors into your space.

Use Lighting to Your Advantage: Proper lighting is essential in highlighting the unique features and quality of your antiques. Use a mix of overhead lighting, spotlights, and even table lamps to create ambiance and draw attention to specific items. Warm, soft lighting can make your space more inviting and enhance the colors and textures of your pieces.

Maximize Space with Vertical Displays: In a limited space, utilizing vertical surfaces is key to displaying more items without cluttering. Use shelves, hanging systems, and tall display cases to draw the eye upwards and make the most of your booth's footprint.

This approach also allows you to create themed displays at different levels, making it easier for customers to browse.

Create Themed Zones: Organize your booth into zones based on theme, era, type of item, or color. This not only makes your booth more navigable but also helps customers with specific interests find what they're looking for more easily. Signage can help distinguish these zones and provide information about the items on display.

Ensure Easy Navigation: Your layout should allow for comfortable browsing, with clear pathways and enough space for visitors to move without feeling crowded. Avoid placing large furniture items in walkways or creating dead ends that can lead to congestion. A layout that encourages a natural flow through the space can enhance the customer experience.

Tell a Story with Your Display: Antiques are rich in history and character, and your booth can reflect that. Use your displays to tell a story, whether it's the history of a particular item, the lifestyle of a certain era, or the craftsmanship behind a collection. This storytelling approach can engage customers on a deeper level, making items more memorable and desirable.

Pay Attention to Detail: Small details can have a big impact on the overall appeal of your booth. Use quality display materials that complement the style of your items, ensure price tags are neat and

unobtrusive, and consider adding decorative elements like vintage fabrics or period-appropriate props to enhance the atmosphere.

Rotate Your Inventory Regularly: Keeping your booth fresh and dynamic is key to attracting repeat visitors. Regularly rotate your inventory, highlighting new acquisitions and rearranging displays to keep the space looking new and interesting. This also gives you the opportunity to adjust your layout and presentation based on what works best for attracting customers.

Interact with Your Space: Finally, your presence in the booth can add a personal touch that makes the space more welcoming. Be available to answer questions and share the stories behind your items, but give customers room to explore on their own. Your passion and knowledge can be the final element that converts interest into a sale.

Creating an Inviting Atmosphere

Creating an inviting atmosphere in your antique booth is about more than just aesthetics; it's about crafting an experience that resonates with visitors, encouraging them to linger, explore, and ultimately connect with the stories behind the items you've curated. The right atmosphere can transform a simple shopping trip into a memorable journey, making customers feel welcomed and intrigued.

Here's how to create a space that captivates and charms your audience:

Engage the Senses: An inviting atmosphere appeals to more than just the visual sense. Soft, ambient lighting can warm up the space, making it more welcoming while highlighting the unique features of your antiques. Consider the use of scent, perhaps through flowers or a subtle fragrance diffuser, to create a pleasant environment—just ensure it's not overpowering or conflicting with the nature of your items. Background music, selected to complement the era or theme of your collection, can enhance the mood and transport customers to a different time.

Use Color and Texture Thoughtfully: The color palette of your booth can significantly impact how visitors feel. Warm, neutral backgrounds can make colorful items pop, while rich, deeper hues can lend a sense of sophistication and depth. Textures, from the

smoothness of polished wood to the softness of an aged textile, invite touch and closer inspection, engaging visitors on a tactile level. Be mindful of balancing colors and textures to avoid visual overload, allowing each piece to stand out on its own.

Create Comfortable Spaces: If space permits, incorporating a small seating area can encourage visitors to sit and contemplate your collection. A vintage settee or a couple of period-appropriate chairs not only add to the booth's aesthetic but also offer a spot for customers to relax and discuss the pieces they've discovered. This small gesture of hospitality can make your booth feel like a destination rather than just another retail space.

Tell Stories: Each antique has a history, and sharing these stories can create an emotional connection that transforms a piece from an object into a treasure. Use tasteful signage, printed cards, or even QR codes that visitors can scan to learn more about the provenance, era, and significance of key pieces. Engaging customers with the narrative behind an item can enrich their experience and spark interest in owning a piece of history.

Personalize the Experience: A warm greeting and a willingness to share your expertise can make visitors feel valued and welcomed. Personalize the experience by asking about their interests and offering insights or stories related to the items they show interest in. This personal touch can turn a casual visitor into a loyal customer.

Maintain Order and Cleanliness: While antiques often come with a sense of time-worn charm, your booth should still be clean, well-organized, and free of dust and clutter. A clean and orderly space is more inviting and makes it easier for customers to navigate your collection without feeling overwhelmed.

Consider the Entry: The entrance to your booth is the first point of interaction with potential customers. Make it inviting with a clear, welcoming entryway. Consider placing a particularly interesting or beautiful item near the entrance to draw visitors in.

Lighting: Lighting plays a crucial role in creating an inviting atmosphere. It should illuminate your items in a flattering way, avoiding harsh shadows or overly bright spots. Use lighting to create zones, highlight focal points, and add depth to your space.

Display Techniques for Antiques

Creating an engaging display for antiques is about more than just showcasing items for sale; it's about crafting an experience that transports customers back in time, evokes emotion, and highlights the unique beauty and history of each piece. Effective display techniques can significantly enhance the appeal of your antiques, encouraging customers to spend more time in your booth and, ultimately, make a purchase. Here's a deep dive into the art of displaying antiques in a way that maximizes their allure.

The foundation of a compelling display is understanding the story behind each item. Antiques aren't just old things; they're artifacts with histories, stories, and intrinsic beauty. Begin by choosing pieces that speak to you or have interesting backgrounds that you think will resonate with your customers. This initial selection process is critical because it sets the tone for your entire display.

Lighting plays a pivotal role in any antique display. The right lighting can make colors richer, textures more pronounced, and details sharper. Use a mix of ambient, task, and accent lighting to create depth and focus. Ambient lighting provides overall illumination, task lighting highlights specific activities or areas, and accent lighting draws attention to particular objects. For example, a

spotlight on a piece of vintage jewelry can accentuate its sparkle, while soft, diffuse light can bring out the depth of a painting.

The layout of your display should invite exploration and discovery. Arrange items at varying heights and depths to create visual interest and encourage customers' eyes to roam. Use shelves, tables, and even stacks of books or boxes to elevate items. Consider creating vignettes or themed groupings that tell a story or evoke a specific time period or style. This technique not only makes your display more engaging but also helps customers imagine how the items might fit into their own lives.

When dealing with a variety of items, balance is key. You want to avoid overcrowding, which can make it difficult for any one piece to stand out, but you also don't want your space to feel sparse. Strive for a layout that allows each item room to breathe while still creating a cohesive overall look. Grouping similar items together can help achieve this balance, making your display both orderly and abundant.

Interaction with the items can also enhance the customer experience. Whenever possible, arrange your display so that items can be easily and safely handled. This tactile interaction can create a personal connection between the customer and the item. However, for particularly fragile or valuable pieces, consider using barriers or

placing them in locked cases, with signage inviting customers to ask for assistance if they'd like a closer look.

Don't overlook the power of signage in your display. Well-crafted signs can provide context, share fascinating histories, or explain the significance of certain items. They can also guide customers through your display, highlighting special pieces or explaining the themes of different sections. Keep your signage consistent in style and easily readable, enhancing the aesthetic of your display rather than detracting from it.

The atmosphere of your booth as a whole contributes significantly to the effectiveness of your display. Elements like background music from the era of your items, subtle scents that evoke the past, or even a carefully chosen rug or curtains can transform your space into a more immersive experience. These sensory touches can transport customers, making them feel as though they're stepping into another time as they browse your collection.

Pricing Your Antiques

Pricing antiques is a nuanced task that requires a deep understanding of the market, the specific items in question, and the broader context in which they exist. The right price can attract knowledgeable buyers while ensuring a fair return on your investment. In the antique world, where items often come with rich histories and unique characteristics, setting prices becomes both an art and a science.

The foundation of effective pricing is research. Understanding the market for your particular type of antique is crucial. This involves studying recent sales of similar items, monitoring auctions, and staying informed about trends in the antique world. Online marketplaces, auction house records, and price guides are valuable resources for this research, offering insight into what collectors are currently paying for similar pieces.

Condition plays a critical role in determining an antique's value. Items in pristine condition, with original parts and minimal wear, typically command higher prices. However, the importance of condition can vary by category; for instance, some collectors might value the patina on silverware, seeing it as a sign of authenticity,

while others might pay a premium for items that appear brand new. Assessing condition involves a careful examination of an item for damage, repairs, or alterations that could affect its value.

Provenance, or the history of an item, can significantly impact its price. Items with a well-documented history or association with significant people, places, or events can be more valuable. Providing buyers with this history not only helps justify the price but also adds to the item's appeal by offering a story that connects the buyer to the past.

Rarity is another crucial factor. Items that are rare, either because they were produced in limited quantities or have survived in few numbers, are typically more valuable. Understanding the rarity of an item requires knowledge of its history and production, as well as the current market availability.

Demand is the final, and perhaps most fluid, factor affecting pricing. Items that are currently in vogue or sought after by collectors can fetch higher prices, even if they are not particularly rare or in the best condition. Keeping a pulse on the market and understanding what collectors are looking for is essential for pricing items in line with demand.

Setting prices also involves a degree of intuition and experience. Over time, dealers develop a sense for what prices the market will bear, based on their interactions with buyers, their successes and failures, and their overall understanding of the market dynamics.

Flexibility in pricing can be a strategic advantage. Being open to negotiation can help close sales, build relationships with buyers, and adjust to the ebb and flow of market demand. However, it's important to set a bottom line based on your research and investment to ensure profitability.

Transparent pricing is key to building trust with buyers. Clearly displaying prices, along with information about an item's condition, history, and any other factors that influence its value, can foster confidence in your pricing and your reputation as a dealer.

In essence, pricing antiques is a complex process that balances objective research with subjective judgment. It involves not just understanding the intrinsic value of an item but also navigating the market's current dynamics. Successful dealers combine thorough research, keen observation, and years of experience to price their antiques in a way that attracts informed buyers and ensures the longevity and profitability of their business.

Factors Influencing Antique Prices

The pricing of antiques is influenced by a tapestry of factors, each adding a layer of complexity to the valuation process. Unlike new items, whose prices are often determined by cost of production and market demand, antiques require a nuanced understanding of various elements that can affect their worth.

Age and Historical Significance: Generally, the older an item, the more valuable it is presumed to be. However, age alone isn't a direct indicator of value; the historical significance of the piece also plays a crucial role. Items from a notable period in history or those that represent a pivotal moment in art or design can command higher prices.

Condition and Originality: The state of an antique is paramount in assessing its value. Items in pristine condition, with original parts and minimal restoration, are typically more desirable. Significant wear, damage, or over-restoration can detract from an item's value, though a well-documented and expertly executed restoration might enhance its appeal to some collectors.

Provenance: The history of an item—its provenance—can significantly influence its price. Antiques with a well-documented lineage, especially those associated with historical figures or events,

are often more valuable. Provenance adds a layer of authenticity and connection to the past that is highly prized.

Rarity: The principle of supply and demand heavily influences antique prices. Items that are rare, either through limited initial production or survival rate over time, tend to be more valuable. Rarity can also apply to unique features of a more common item, such as an unusual design, color, or modification.

Market Demand: Trends in the antiques market can vary widely, with certain items or styles becoming fashionable (and thus more valuable) at different times. Market demand can be influenced by factors such as interior design trends, collector interest, and even popular culture.

Craftsmanship and Maker: The quality of craftsmanship and the reputation of the maker are critical factors. Items crafted by renowned artists, designers, or manufacturers, or those that exemplify a high level of skill, can attract premium prices. A maker's mark or signature can significantly enhance an item's desirability and value.

Authenticity: Ensuring an item is genuine is crucial, as reproductions or forgeries can significantly impact the market. Authentic items, verified through expert appraisal or historical documentation, are more valuable. Collectors and enthusiasts are

willing to pay a premium for pieces whose authenticity is beyond doubt.

Size and Practicality: The size of an antique can affect its price, with larger items like furniture sometimes commanding higher prices due to their utility and visual impact. However, practical considerations, such as the ease of display or storage, can also influence a buyer's willingness to pay a certain price.

Cultural and Regional Significance: Items with cultural or regional significance can be more valuable within certain markets. Pieces that are emblematic of a particular area's history, craftsmanship, or artistic traditions may fetch higher prices from collectors with an interest in that region.

Pricing Strategies for Your Items

Pricing strategies for antiques involve a delicate balance between understanding the intrinsic value of your items and aligning this with market demand and consumer expectations. Unlike new products, where pricing can often be determined by cost plus markup, antiques require a nuanced approach that takes into account their history, rarity, condition, and the current trends in the market.

To start, conducting thorough research is foundational. This means looking at auction results, checking prices in antique shops and online marketplaces, and consulting price guides and appraisers. Comparing similar items and understanding price variations based on different factors is crucial. This research provides a baseline, but remember, the price an item can command in one venue might differ from another due to factors like client demographics and sales platform fees.

Understanding the provenance and authenticity of your items can significantly impact pricing. Provenance adds a layer of storytelling and history that can elevate an item's desirability and value. Similarly, ensuring and proving authenticity, through expert opinions or certificates, can justify higher prices. These elements not only contribute to an item's monetary worth but also its appeal to collectors who value the story and history as much as the item itself.

Condition plays a pivotal role in pricing antiques. Items in excellent condition without need for restoration are generally more valuable than those that have been significantly restored or are in poor condition. However, the extent to which condition affects price can vary by category. For example, some collectors may value the untouched patina on a piece of furniture, viewing it as part of its history, while others might pay more for a piece in pristine condition.

The rarity of an item is a significant pricing factor. The rarer an item, the higher the price it can command, especially if there's demand. However, rarity alone doesn't dictate price; it must be coupled with desirability. An item can be rare because it wasn't popular or widely used, which might not translate to high demand now. Therefore, aligning rarity with current trends and collector interest is key.

Market demand influences pricing strategies extensively. Demand can fluctuate based on trends, the economic climate, and changing tastes among collectors. Being adaptable and aware of these shifts allows you to adjust prices to reflect current interest levels. For instance, if mid-century modern furniture is experiencing a surge in popularity, prices for items in this category might increase.

Setting your prices also involves considering the sales channel. Items sold online might be priced differently than those in a brick-and-mortar antique shop due to differences in overhead costs, the customer base, and the level of competition. Additionally, pricing flexibility can be a strategic tool, allowing for negotiation with serious buyers while still maintaining a fair profit margin.

Building a reputation for fair pricing and quality items can also influence your pricing strategy over time. Establishing trust with your customers encourages repeat business and referrals, potentially allowing for slightly higher pricing due to the value placed on your expertise and the assurance of authenticity and quality.

Psychological pricing tactics, such as pricing items just below a round number (e.g., $99 instead of $100), can make prices seem more attractive to buyers. While this strategy is more commonly used in traditional retail, it can be adapted to the antique market, particularly for less expensive items.

Negotiation Tips with Customers

Negotiating with customers over the price of antiques can be a nuanced dance. It requires a blend of empathy, strategic thinking, and a deep understanding of the value of your items. Effective negotiation ensures both you and the customer feel satisfied with the transaction, fostering goodwill and potentially establishing lasting relationships.

Here's how to navigate negotiations in the antique business with finesse and integrity:

Start by setting realistic prices for your items based on thorough research and understanding of the market. This preparation ensures you enter negotiations with a clear sense of your item's worth, allowing you to explain your pricing to customers with confidence. Be ready to share the story behind an item, including its history, rarity, and any unique features, as this can enhance its perceived value.

It's important to listen to what the customer is saying during a negotiation. Sometimes, their offer or hesitation provides insight into their budget or how much they value the item. Understanding their perspective can guide you in making counteroffers that align with their expectations while still ensuring you get a fair price.

Flexibility is key in negotiations. While you should have a clear bottom line, be open to creative solutions that meet both your and the customer's needs. This could involve offering a discount on the purchase of multiple items, throwing in a smaller item as a bonus, or offering layaway or installment payment plans. Such flexibility can turn a no into a yes without significantly compromising on price.

Building rapport with customers is also crucial. People are more likely to buy from someone they like and trust. Engage in friendly conversation, show genuine interest in their needs, and demonstrate your expertise without being overbearing. A positive relationship can make negotiations smoother and more successful.

Transparency about pricing can help build trust. If a customer understands why an item is priced a certain way, they may be more inclined to accept that price or negotiate respectfully. Be open about your pricing criteria, such as the item's condition, provenance, and how it compares to similar items in the market.

Know when to stand firm. Some items may have a non-negotiable price due to their rarity, value, or personal significance to you. In these cases, politely but firmly explain why the price is fixed. Customers will respect your knowledge and conviction, even if it means they don't end up making the purchase.

Don't take negotiations personally. Remember, negotiation is a normal part of doing business in the antique market. A customer's attempt to negotiate doesn't reflect on you or your items' worth but is simply a part of the buying process. Maintain a professional demeanor, and even if you can't reach an agreement, part on good terms. The same customer may return in the future for a different item or recommend your booth to others because of how well the negotiation was handled.

Effective negotiation is an art that can lead to successful sales and satisfied customers. By preparing thoroughly, listening actively, being flexible, and maintaining a positive rapport, you can navigate these discussions with ease, enhancing both your reputation and your bottom line.

Marketing and Promotion

In the evolving landscape of the antique business, effective marketing and promotion strategies are crucial for standing out in a crowded marketplace. The goal is to not only attract more customers but also build a brand that resonates with enthusiasts and collectors alike. Here's a comprehensive approach to marketing and promoting your antique booth or store.

Develop a Strong Brand Identity: Your brand is what sets you apart from competitors. It encompasses your logo, color scheme, messaging, and the overall feel of your business. A strong brand identity should reflect the uniqueness of your collection and appeal to your target market. It's important to be consistent in your branding across all platforms and materials, from your signage at the booth to your online presence.

Leverage Social Media: Social media platforms like Instagram, Facebook, and Pinterest are invaluable for marketing antiques. They allow you to showcase your items through high-quality photos and engaging stories, connect with customers and other dealers, and update followers on new arrivals and special events. Regular posts that highlight the stories behind specific pieces can create interest and draw customers to your booth or online store.

Create an Engaging Online Presence: A well-designed website or online store can significantly expand your reach beyond the local market. It should be visually appealing, easy to navigate, and updated regularly with your latest items and their stories. Including a blog where you share insights about antiques, collecting tips, and the history of specific items can enhance your website's appeal and help establish you as an expert in your field.

Utilize Email Marketing: Collecting email addresses from customers and interested visitors allows you to keep them informed about new inventory, upcoming sales, or events. Email newsletters can be a powerful tool for building relationships with your customer base, offering exclusive content or early access to sales as incentives for subscribers.

Participate in Antique Shows and Fairs: Exhibiting at antique shows and fairs can not only increase sales but also enhance your visibility in the antique community. These events are excellent opportunities for networking, learning about market trends, and gaining new customers who may not visit your primary location.

Offer Workshops or Appraisal Services: Hosting workshops on antique collecting, preservation techniques, or the history of specific types of antiques can attract enthusiasts and novices alike. Offering appraisal services or hosting appraisal events can also draw people

to your booth or store, providing additional revenue streams and marketing opportunities.

Collaborate with Interior Designers and Decorators: Building relationships with interior designers and decorators can open up new markets for your antiques. These professionals are always on the lookout for unique pieces for their clients, and establishing a go-to partnership can be mutually beneficial.

Leverage Local Media and Community Events: Getting featured in local newspapers, magazines, or blogs can increase your visibility within the community. Participating in local events, charity auctions, or community fairs can also raise your profile and attract new customers.

Utilize Customer Reviews and Testimonials: Positive word-of-mouth is incredibly powerful in the antique business. Encourage satisfied customers to leave reviews online or provide testimonials that you can use in your marketing materials. Potential customers are often reassured by the positive experiences of others.

Branding Your Antique Booth

Branding your antique booth is about creating a memorable identity that resonates with your customers, distinguishing you from competitors and building a loyal following. It's a strategic process that encompasses the visual, emotional, and experiential aspects of your business, ensuring that every interaction customers have with your booth reinforces your brand values and aesthetic. Effective branding can transform a simple booth into a destination for collectors and enthusiasts alike.

The foundation of a strong brand is a clear understanding of your unique selling proposition—what makes your collection distinct, whether it's a focus on a specific era, a type of item, or a particular style. This uniqueness should be reflected in all elements of your branding, from your name and logo to the design of your booth and the way you interact with customers.

Your brand name and logo are the first points of contact with potential customers, so they should be memorable, evocative, and reflective of the antique items you specialize in. A well-designed logo that appears on your signage, business cards, and promotional materials can significantly enhance brand recognition. It should resonate with the era or style of antiques you sell, whether through typography, imagery, or color scheme.

The design and layout of your booth are also crucial components of your branding. Your booth should not only be a place to display and sell antiques but also an immersive experience that transports customers to another time or place. Consider the overall theme and feel of your booth—whether it's elegant and refined, rustic and charming, or eclectic and whimsical—and ensure that every element, from display cases to price tags and signage, aligns with this aesthetic.

Creating a consistent and engaging customer experience is key to effective branding. This includes the way you greet and interact with customers, the stories you tell about your items, and the knowledge you share. Personal touches, such as handwritten signs or personalized recommendations, can make customers feel valued and enhance their connection to your brand.

Marketing and promotion play a significant role in branding your antique booth. Utilize social media platforms to share beautiful images of your items, stories of their history, and behind-the-scenes glimpses of your sourcing trips or booth setup. An engaging online presence can extend the reach of your brand and attract customers to your booth, even before they meet you in person.

Customer feedback and engagement are invaluable for refining your brand. Listen to what customers say about your booth, the items they're drawn to, and the aspects they appreciate most. This feedback can guide adjustments to your branding strategy, ensuring it remains relevant and appealing to your target audience.

Branding your antique booth is an ongoing process that evolves with your business. It's about weaving the essence of your collection into a compelling narrative that captivates customers, making your booth not just a place to shop but a memorable part of their collecting journey. Through thoughtful branding, you can create a strong, recognizable presence in the antique market, attracting loyal customers and distinguishing your booth as a treasure trove of history and beauty.

Effective Marketing Strategies

Effective marketing strategies for an antique booth business encompass a blend of traditional and digital approaches, tailored to connect with a specific audience while broadening the overall reach. The unique nature of antiques, each with its own story and history, offers rich material for engaging marketing campaigns.

Here's how you can leverage various strategies to effectively market your antique business:

Storytelling through Content Marketing: Utilize the unique backgrounds of your antiques as a powerful tool for content marketing. Blog posts, social media content, and email newsletters that tell the stories behind your pieces can captivate potential buyers. Highlight the history, craftsmanship, and any interesting previous ownership to add depth and value to your items. This approach not only markets the antiques but also establishes your brand as knowledgeable and passionate.

Social Media Engagement: Platforms like Instagram, Pinterest, and Facebook are ideal for visual-based businesses like antiques. Regular posts featuring high-quality images of your items, behind-the-scenes looks at your sourcing trips, and even customer stories can create a community around your brand. Engaging directly with

followers through comments, stories, and live videos can further personalize the customer experience.

Online Presence and SEO: A well-designed website or online store serves as the digital storefront for your antique business, allowing customers to browse your collection from anywhere. Optimizing your site for search engines (SEO) by using relevant keywords, such as the types of antiques you specialize in and their historical periods, can help attract organic traffic. Including a blog on your site can also improve SEO and provide a platform for more in-depth storytelling and expertise sharing.

Email Marketing: Collecting email addresses from booth visitors and online customers allows you to keep your audience engaged with regular updates. Email campaigns can promote new arrivals, exclusive sales, and upcoming events. Personalization, based on previous purchases or expressed interests, can make your emails more effective.

Networking and Partnerships: Building relationships with interior designers, vintage clothing stores, and other businesses that share a similar customer base can open up cross-promotional opportunities. Collaborating on events or features in each other's newsletters or social media can introduce your brand to a wider audience.

Leverage Customer Reviews and Testimonials: Positive word-of-mouth is particularly powerful in the antiques market, where trust and credibility are paramount. Encourage satisfied customers to leave reviews on your website, Google, or social media. Sharing these testimonials can reassure potential buyers of the quality and authenticity of your items.

Participate in Antique Shows and Fairs: Attending these events can not only result in direct sales but also increase visibility for your brand. They offer networking opportunities with fellow dealers and a chance to build a mailing list of interested customers. Highlighting your participation through your marketing channels can draw more visitors to your booth.

Traditional Advertising: While digital marketing is crucial, traditional methods like print ads in local magazines or newspapers, flyers, and business cards can still be effective, especially for reaching local markets or specific demographics. Consider advertising in publications read by antique collectors or at local community boards.

Offer Workshops or Talks: Hosting workshops on antique restoration, history, or valuation can position you as an expert in your field while attracting potential customers to your business. These events can be marketed through your digital channels, local media, and partnerships.

Combining these strategies creates a comprehensive marketing plan that leverages the unique appeal of antiques. By engaging customers with the stories behind your items, maintaining a strong online presence, and utilizing both digital and traditional marketing tactics, you can attract a dedicated following and drive sales for your antique booth business.

Utilizing Social Media for Promotion

Utilizing social media for promotion is an indispensable strategy for antique businesses looking to connect with a wider audience, engage customers, and enhance brand visibility. Social media platforms offer a unique opportunity to showcase the stories behind antique items, highlight their beauty, and build a community of enthusiasts and potential buyers.

Here's how to effectively leverage social media for promoting your antique business:

Choose the Right Platforms: Not all social media platforms are created equal, especially when it comes to promoting antiques. Instagram and Pinterest are particularly suited for visual-centric antique businesses, allowing for the display of high-quality images and stories about the items. Facebook can facilitate community building through groups and pages, while TikTok offers a platform for creative storytelling through short videos.

Tell a Story: Antiques are rich in history and character, making storytelling a powerful tool for engagement. Use your social media posts to tell the stories behind your items, including their historical significance, unique features, or any interesting provenance. This approach not only adds value to the items but also engages your audience on a deeper level.

High-Quality Visual Content: The visual appeal of antiques can be a major selling point. Invest time in taking high-quality photos or videos that highlight the detail, craftsmanship, and condition of your items. Use natural lighting and avoid cluttered backgrounds to ensure your pieces stand out. Short videos or reels showcasing the items from different angles or in use can also enhance engagement.

Consistent Posting Schedule: Maintaining a consistent posting schedule keeps your audience engaged and helps build a loyal following. Plan your content in advance and consider using social media management tools to schedule posts for optimal times. Regular updates, stories, and live sessions can keep your audience interested and looking forward to your posts.

Engage With Your Audience: Social media is a two-way communication channel. Make an effort to respond to comments, messages, and questions promptly. Engaging with your audience builds a sense of community and can foster loyalty and trust.

Encourage your followers to share their own stories or experiences with antiques, further enriching the community.

Use Hashtags and Tags Wisely: Hashtags can significantly increase the visibility of your posts to people who don't follow you yet. Use relevant hashtags related to antiques, your specific niche, and broader lifestyle or design trends. Tagging brands, collaborators, or related accounts can also broaden your reach and encourage cross-promotion.

Promotions and Giveaways: Occasionally running promotions, discounts, or giveaways can drive engagement and attract new followers. Ensure that any promotions are clearly outlined and comply with the platform's rules. Highlighting exclusive social media offers can also encourage your followers to stay active and engaged with your content.

Leverage User-Generated Content: Encourage your customers to share their own photos or stories featuring your antiques and repost this content on your own channels. User-generated content can provide social proof, showing potential customers the beauty and value of your items in real-world settings.

Analyze Your Performance: Most social media platforms offer analytics tools that allow you to track the performance of your posts, including reach, engagement, and follower growth. Regularly

reviewing these metrics can help you understand what content resonates with your audience, allowing you to refine your strategy over time.

Networking in the Antique Community

Networking within the antique community is a multifaceted endeavor that involves building relationships with fellow dealers, collectors, experts, and enthusiasts. It's about creating a web of connections that can support your business through shared knowledge, opportunities for collaboration, and access to a wider range of items. Effective networking can also enhance your reputation and establish you as a knowledgeable and trustworthy figure within the antique world.

One of the primary ways to network is by attending antique shows, auctions, and fairs. These events bring together a diverse group of people from all corners of the antique community. Participating not only allows you to buy and sell but also serves as an opportunity to meet new people, exchange information, and learn about trends and developments in the market. Engaging in conversations, asking questions, and sharing your own insights can help forge meaningful connections.

Joining local and national antique clubs and associations is another effective networking strategy. These organizations often host meetings, lectures, and events, providing regular opportunities for interaction with like-minded individuals. Membership can also offer benefits such as access to exclusive resources, newsletters, and forums where members can ask for advice, share discoveries, and discuss challenges.

Social media platforms, particularly those focused on visual content like Instagram and Pinterest, are powerful tools for networking in the antique community. By following and engaging with other antique dealers, collectors, and enthusiasts, you can build relationships, learn from others, and showcase your items to a broader audience. Regular posting, commenting on others' posts, and sharing stories can help maintain an active and engaging presence.

Creating or participating in online forums and discussion groups dedicated to antiques is another way to connect with peers. These platforms allow for deeper discussions on specific topics, from identifying and valuing items to restoration tips and historical research. Contributing helpful advice and sharing your expertise can raise your profile and lead to valuable connections.

Collaborations with other dealers or related businesses, such as interior designers, vintage clothing stores, or historical societies, can also broaden your network. Joint events, cross-promotions, or simply referring customers to each other can be mutually beneficial and strengthen your ties within the community.

Beyond formal settings, informal gatherings, such as local meetups, study groups, or even casual conversations at your booth, can lead to meaningful relationships. The antique community is often driven by a shared passion for history and craftsmanship, and these informal interactions can solidify bonds and open doors to new opportunities.

Giving back to the community through mentorship, volunteering, or contributing to charitable events can not only be personally rewarding but also help you meet new people and strengthen your connections. Being generous with your time and knowledge can establish you as a valuable member of the antique community and lead to lasting relationships.

Participating in Antique Shows and Events

Participating in antique shows and events is a cornerstone activity for antique dealers, offering a blend of sales opportunities, networking, learning, and community engagement. These events range from local flea markets and pop-up shops to prestigious antique fairs and international shows, each providing a unique platform for showcasing your collection to a diverse audience. The experience of participating in such events is not just about selling antiques but also about immersing yourself in the broader antique community, gaining insights, and establishing your presence in the market.

The first step in participating in antique shows and events involves selecting the right ones to attend. This decision should be based on several factors, including the event's target audience, its geographical location, and the types of items typically featured. You'll want to choose events that attract collectors and enthusiasts interested in your specific niche or style of antiques. Researching past events, reading reviews, and consulting with fellow dealers can help identify the shows that offer the best fit for your collection and business goals.

Once you've selected an event, preparation is key to a successful experience. This includes everything from registering for the event, understanding the logistical aspects such as booth size, setup times, and any specific regulations, to planning the layout and design of your booth. Creating an inviting and visually appealing display that highlights the unique qualities of your antiques can attract more visitors and encourage sales. It's also important to have a clear pricing strategy and to be prepared to discuss the history and significance of your items with potential buyers.

Marketing your participation in the event is another crucial aspect. Utilizing social media, email newsletters, and your website to announce your attendance and preview some of the items you'll be bringing can generate interest and excitement among your customers and followers. Offering special promotions or VIP previews for your contacts can further enhance your booth's appeal.

During the event, engaging with visitors in a friendly and knowledgeable manner can leave a lasting impression, turning casual browsers into loyal customers. Being able to share the stories behind your items, offering insights into their historical context, and providing advice on antique collection and care can distinguish you from other dealers and build your reputation as an expert in your field.

Networking with fellow dealers, organizers, and enthusiasts at the event is also invaluable. These interactions can lead to collaborative opportunities, expand your professional network, and provide insights into market trends and business strategies. Antique shows and events are community gatherings as much as they are commercial ventures, and participating actively in the community can open many doors.

After the event, follow-up is essential. This could involve reaching out to contacts you made during the show, following up on leads, or sending thank-you notes to customers who made purchases. Analyzing what worked well and what could be improved for future events can help refine your approach and ensure continued success.

Sales and Customer Service

Sales and customer service in the antique business are profoundly interwoven, shaping the customer's experience and directly influencing the success of your venture. This aspect of the business goes beyond mere transactions, embodying the art of creating lasting relationships, fostering trust, and ensuring satisfaction with each purchase. The unique nature of antiques with each item having its own story and value requires a nuanced approach to sales and customer service.

In the realm of antiques, every interaction is an opportunity to educate and inspire your customers. Knowledge about the provenance, era, craftsmanship, and care of each piece not only adds value to the item but also enriches the buying experience. Sharing stories about the pieces and offering insights into their historical significance can turn a simple transaction into an unforgettable experience, encouraging repeat business and word-of-mouth recommendations.

Listening plays a crucial role in sales and customer service. Understanding what the customer is looking for, whether it's a specific item, a piece from a certain period, or something within a budget, allows you to tailor your approach and make relevant suggestions. Listening also helps in identifying the level of knowledge a customer has about antiques, enabling you to provide information that enhances their appreciation and understanding of the items, without overwhelming them.

The presentation of your items is another critical factor. Antiques should be displayed in a way that highlights their best features and makes them easily accessible for inspection. Clear, honest descriptions of the condition, any restorations, and the item's history are essential. Transparency about the item's condition and authenticity builds trust and helps avoid post-purchase dissatisfaction.

Flexibility in pricing and negotiation can also enhance customer service. Being open to reasonable offers and willing to discuss the price demonstrates that you value the customer's interest in your items. Offering layaway plans or accepting various payment methods can make purchases more feasible for customers, increasing sales and fostering goodwill.

After-sales service is just as important in the antique business as the initial sale. Offering advice on the care and preservation of items, providing documentation of authenticity, and being available to answer any questions after the purchase reinforces your commitment to customer satisfaction. A satisfied customer is more likely to return and recommend your business to others.

Handling complaints and resolving issues promptly and fairly is crucial. In situations where a customer is dissatisfied, listening to their concerns, empathizing with their situation, and offering fair solutions can turn a potentially negative experience into a positive one. This approach not only resolves the immediate issue but can also strengthen the customer's trust and loyalty to your business.

Building relationships with customers through personalized service, such as remembering their preferences, celebrating their significant purchases, or reaching out with items that match their interests, can create a loyal customer base. Personal touches, like handwritten thank-you notes or follow-up messages to ensure satisfaction with a purchase, add a level of care that sets your business apart.

In essence, sales and customer service in the antique business are about more than just transactions; they're about creating an engaging, educational, and satisfying experience for each customer. By focusing on knowledge sharing, attentive listening, transparency, flexibility, and personalized service, you can cultivate

lasting relationships with customers, enhance the reputation of your business, and ensure its long-term success.

Selling Techniques for Antique Dealers

Selling antiques requires a blend of passion, knowledge, and strategic sales techniques. Since each piece has its unique history and character, antique dealers must employ a nuanced approach to sales that not only highlights the value of their items but also resonates with the interests and desires of their customers.

Here are key selling techniques tailored for antique dealers:

Storytelling: Perhaps the most powerful tool in an antique dealer's arsenal is the ability to tell compelling stories about their items. The history, provenance, and unique characteristics of each piece can significantly enhance its appeal. Stories create emotional connections and can transform a simple object into a treasured heirloom, making storytelling a vital technique in selling antiques.

Educate Your Customers: An educated customer is more likely to appreciate the value of antiques. Share your knowledge about different periods, styles, and makers. Teach them how to identify

marks of authenticity and the significance of certain designs or motifs. This not only builds trust but also enriches the customer's shopping experience and can make them more confident in their purchases.

Personalization: Tailoring your approach to each customer's interests and preferences can significantly increase sales. Listen carefully to their needs and desires, then suggest items that align with their tastes or the specific collection they're building. Personalized recommendations demonstrate your commitment to customer satisfaction and can lead to repeat business.

Visual Merchandising: The way you display your antiques can greatly impact their desirability. Create attractive, themed displays that highlight the beauty and uniqueness of your pieces. Use lighting effectively to draw attention to key items and arrange pieces in a way that encourages customers to browse and discover. A well-curated presentation can make all the difference in selling antiques.

Flexibility in Pricing and Negotiations: Being open to negotiation is important in the antique business. While you should have a clear understanding of each item's value to ensure fair pricing, be prepared to discuss prices with customers. Offering a small discount or being flexible with payment terms can close a sale while maintaining a positive relationship with the customer.

Utilize Digital Platforms: In today's market, an online presence can significantly enhance your sales reach. Use social media, online marketplaces, and your website to showcase your inventory to a wider audience. High-quality photographs and detailed descriptions can attract online buyers, while regular updates keep them engaged with your offerings.

Create an Experience: Shopping for antiques is often more about the experience than the transaction. Create an inviting atmosphere in your store or booth that makes customers feel welcome and intrigued. Hosting events, offering appraisals, or simply sharing a cup of coffee can create memorable experiences that encourage customers to return.

Offer Exceptional Customer Service: Excellent customer service is crucial in selling antiques. Be approachable, knowledgeable, and helpful, but not overbearing. Offer information about the care and preservation of items, provide detailed receipts that include an item's description and condition, and follow up on purchases to ensure satisfaction. Word-of-mouth from satisfied customers can be one of your best sales tools.

Build a Network: Networking with other dealers, collectors, and enthusiasts can open up new sales channels and opportunities for

collaboration. Attend antique shows, join local and national antique associations, and participate in online forums to connect with others in the antique community.

Incorporating these selling techniques can help you not only close sales but also build lasting relationships with customers who share your passion for antiques. By combining deep knowledge of your items with personalized service and strategic marketing, you can enhance the visibility and appeal of your antiques, ensuring the success and sustainability of your business.

Enhancing Customer Experience

Enhancing the customer experience in the antique business is about creating a memorable and engaging journey that begins the moment a customer steps into your booth or visits your online store. Given the unique nature of antiques, each with its own story and historical significance, your approach should not only focus on the transaction but also on educating, engaging, and inspiring your customers. Here are comprehensive strategies to elevate the customer experience in the world of antiques.

Create an Inviting Atmosphere: For brick-and-mortar booths or shops, the ambiance plays a crucial role in welcoming customers

and setting the tone for their visit. Use warm lighting, pleasant background music, and thoughtful decoration to create an environment that encourages customers to explore and linger. For online stores, a clean, easy-to-navigate website with high-quality images and detailed descriptions can create a virtual atmosphere that's just as inviting.

Personalize the Shopping Experience: Personalization can significantly enhance the customer experience. Pay attention to your customers' interests and preferences, and tailor your interactions accordingly. Offer personalized recommendations based on their past purchases or expressed interests. For returning customers, acknowledging their previous selections or even remembering their names can make them feel valued and deepen their connection to your business.

Educate and Share Knowledge: Many customers are drawn to antiques not just for their beauty but for their history and the stories they hold. Share your knowledge about the era, craftsmanship, or the unique backstory of the items they're interested in. Offering educational content, whether through in-person conversations, signage, blog posts, or social media stories, can enrich the customer's experience and position you as a trusted expert.

Encourage Interaction: Allowing customers to physically interact with items, where appropriate, can create a more engaging shopping

experience. For online customers, providing detailed videos or virtual tours can offer a similar interactive experience. Encourage questions and offer detailed answers that highlight the item's features and historical context.

Offer Exceptional Service and Support: Customer service extends beyond the point of sale. Offer support in terms of shipping, handling, and advice on care and maintenance of the items. For online purchases, ensure your packaging is secure and reflects the quality of your brand. A follow-up message to confirm the item's safe arrival and satisfaction can also enhance the post-purchase experience.

Simplify the Purchasing Process: Whether in-person or online, the process of purchasing an antique should be as smooth and hassle-free as possible. Offer multiple payment options, clearly display prices and policies, and provide assistance for any queries or concerns. For online sales, ensure the checkout process is straightforward and secure.

Solicit Feedback and Act on It: Feedback is invaluable for improving the customer experience. Encourage customers to share their thoughts on your service, collection, and overall shopping experience. Actively listen to their feedback and be willing to make changes based on their suggestions. This not only improves the

experience for future customers but also shows that you value and respect their opinions.

Build a Community: Fostering a sense of community among your customers can greatly enhance their experience. Host events, workshops, or talks that bring antique enthusiasts together. For online businesses, creating a forum or social media group where customers can share their finds, stories, and tips can replicate the community aspect virtually.

Managing Customer Inquiries and Complaints

Managing customer inquiries and complaints is a critical aspect of customer service, especially in the antique business, where items often come with significant history and value. Effective handling of these interactions not only resolves immediate issues but also builds trust and loyalty, turning potential negative experiences into positive outcomes.

Here's how to approach inquiries and complaints with professionalism and care:

Prompt Response: Time is of the essence when dealing with customer inquiries and complaints. A prompt response shows customers that their concerns are important to you. Even if a complete resolution isn't immediately available, acknowledging their inquiry or complaint and providing a timeline for resolution can go a long way in maintaining trust.

Active Listening and Empathy: Listen carefully to what the customer is saying without interrupting. Understanding the issue fully before responding is crucial. Express empathy for their situation. Showing that you genuinely care about their concern and are there to help can diffuse tension and make the customer feel valued.

Clear Communication: Communicate clearly and avoid using jargon that may not be familiar to the customer. Be honest about what you can do to address their concern and explain the steps involved in resolving their issue. Clear communication prevents misunderstandings and sets realistic expectations.

Seek Solutions: Focus on finding a solution that satisfies the customer while being feasible for your business. Sometimes, this may involve offering a repair, replacement, refund, or another form of compensation. Be creative and flexible in resolving issues, always aiming to turn a dissatisfied customer into a satisfied one.

Follow-Up: After addressing the customer's concern, follow up to ensure they are satisfied with the resolution. This could be a follow-up call, email, or even a personal note, depending on the nature of the complaint and your business style. Following up shows that you value their satisfaction in the long term, not just resolving the immediate issue.

Document and Learn: Keep records of customer inquiries and complaints, along with the resolutions provided. This documentation can be a valuable resource for identifying patterns or recurring issues, which can inform improvements in your products, services, or policies. Learning from these interactions can help you prevent similar issues in the future.

Train Your Staff: If you have employees, ensure they are trained in handling customer inquiries and complaints effectively. They should be familiar with your products, policies, and procedures for resolving issues. Empower them to make decisions that enhance customer satisfaction, within defined limits.

Use Positive Language: Frame your responses with positive language that focuses on the solutions rather than the problem. For example, instead of saying "We can't do that," try "Here's what we can do." Positive language can change the tone of the interaction and lead to a more favorable outcome.

Maintain Professionalism: Regardless of the nature of the complaint or the customer's demeanor, always maintain professionalism. Keeping a calm and courteous demeanor, even in the face of criticism, reflects well on your business and can help de-escalate potentially heated situations.

Invite Feedback: Encourage customers to provide feedback on how their inquiry or complaint was handled. This not only gives them a voice but also provides you with insights into how your processes can be improved.

Effectively managing customer inquiries and complaints is an opportunity to demonstrate your commitment to customer service and to strengthen your relationships with your customers. By approaching these interactions with promptness, empathy, clarity, and a focus on resolution, you can enhance customer satisfaction and loyalty, contributing to the success and reputation of your antique business.

Building Customer Loyalty

Building customer loyalty in the antique business transcends the mere act of selling; it involves creating lasting relationships, fostering trust, and providing an experience that keeps customers coming back. Given the unique and often personal nature of antiques, the opportunity to build a deeply loyal customer base is significant.

Here's how to cultivate loyalty among your clientele:

Offer Exceptional Customer Service: Outstanding customer service is the cornerstone of customer loyalty. This means not only being friendly and helpful during transactions but going above and beyond to make the shopping experience memorable. Offering expert knowledge, sharing the histories of items, and providing personalized recommendations can make customers feel valued and respected.

Create a Personal Connection: Personal connections can turn occasional customers into loyal ones. Learn your customers' names, remember their preferences, and show genuine interest in their collecting journey. A personal touch, such as following up on how an item fits into their collection, can make customers feel connected to your business on a personal level.

Maintain High-Quality Inventory: Consistently offering high-quality, authentic antiques is key to building trust and loyalty. Customers need to feel confident in the quality and authenticity of their purchases. Providing detailed information and provenance for items can further enhance this trust.

Implement a Loyalty Program: Consider implementing a loyalty program that rewards repeat customers. This could be as simple as a punch card system leading to a discount after a number of purchases or more sophisticated rewards for different levels of spending. Loyalty programs not only encourage repeat business but also make customers feel appreciated.

Solicit and Act on Feedback: Listening to your customers' feedback and making changes based on their suggestions shows that you value their input and are committed to improving their experience. Whether it's feedback about your inventory, store layout, or customer service, acting on this information can significantly enhance customer satisfaction and loyalty.

Leverage Social Media and Email: Keep in touch with your customers through social media and email newsletters. Share new arrivals, stories about unique items, and behind-the-scenes glimpses

of your business. Regular, engaging communication keeps your store top of mind and can draw customers back.

Host Events: Hosting events, such as antique appraisals, history talks, or restoration workshops, can create a sense of community among your customers. These events offer more than just shopping—they provide a learning experience and an opportunity to engage with fellow enthusiasts.

Offer Exclusive Previews: Give your most loyal customers exclusive previews of new arrivals or the first chance to purchase rare items. This exclusivity makes them feel valued and can increase their loyalty to your business.

Provide Exceptional After-Sales Service: The relationship with your customers shouldn't end at the sale. Offering excellent after-sales service, including advice on care and maintenance, answering any questions about the item, and handling any issues promptly, reinforces their decision to purchase from you.

Express Appreciation: Simple acts of appreciation, such as thank you notes, small gifts, or discounts on future purchases, can make a big difference in how customers perceive your business. Recognizing and thanking your customers for their loyalty fosters a positive relationship and encourages continued patronage.

Online Sales and Presence

Establishing a robust online sales and presence is crucial for antique dealers in today's digital age. The internet offers an expansive platform to reach a global audience, far beyond the limitations of a physical storefront or booth. An effective online strategy encompasses several components, from showcasing your inventory to engaging with customers and managing transactions securely. Here's how to build and enhance your online sales and presence in the antique business:

Creating a visually appealing, user-friendly website is the cornerstone of your online presence. This site acts as your digital storefront, where customers can explore your collection, learn about the history and stories behind each piece, and make purchases. High-quality photographs that capture the details and true essence of each item are essential. Each listing should include a detailed description covering the item's age, provenance, condition, and any other information that might interest a collector. Including a blog on your website where you post about new acquisitions, share collecting

tips, and delve into the history of specific antiques can drive traffic to your site and help establish you as an expert in your field.

Leveraging social media platforms like Instagram, Pinterest, and Facebook can significantly enhance your online presence. These platforms are ideal for showcasing your items, sharing behind-the-scenes glimpses of your sourcing adventures, and building a community around your brand. Engage with your followers through comments, direct messages, and interactive stories to create a sense of connection and loyalty. Regular, engaging posts that highlight the uniqueness of your inventory can attract followers and direct traffic to your website.

Online marketplaces such as eBay, Etsy, and 1stdibs can be powerful channels for reaching customers who are actively searching for antiques. These platforms have built-in audiences and offer ease of use for both sellers and buyers. While listing your items on these platforms, ensure your brand identity remains consistent, and leverage their tools for analytics, shipping, and promotions to optimize your sales.

Email marketing is an effective tool for maintaining contact with your customers and keeping them informed about new arrivals, exclusive offers, and upcoming events. Collect email addresses both online and at any physical sales events you attend. Segment your

email list based on customers' interests to personalize your communications, making them more relevant and engaging.

Customer service doesn't end with the sale, especially in the online world. Offer comprehensive support that covers secure payment options, reliable shipping, and clear return policies. Providing detailed condition reports and additional photographs upon request can help online buyers feel confident in their purchases. After a sale, follow up with customers to ensure their satisfaction and address any concerns promptly. This level of service can foster trust and encourage repeat business.

Encouraging online reviews and testimonials from satisfied customers can bolster your reputation and attract new buyers. Positive feedback on your website, social media platforms, and online marketplaces serves as social proof, reassuring potential customers of your reliability and the quality of your items.

Building a strong online sales and presence requires consistent effort, high-quality content, and excellent customer service. By effectively utilizing your website, social media, online marketplaces, and email marketing, you can reach a wider audience, establish your brand in the digital antique market, and create meaningful connections with customers around the world.

Creating an Online Store for Your Antiques

Creating an online store for your antiques is a strategic move that can significantly expand your reach and sales potential. In today's digital age, customers increasingly seek the convenience of browsing and purchasing items online. For antique dealers, an online store offers the opportunity to showcase your collection to a global audience, operate beyond the constraints of physical location and traditional operating hours, and connect with customers who share a passion for antiques. Here's a detailed guide on setting up an effective online store for your antique business:

Choose the Right Platform: The first step is selecting an e-commerce platform that suits your needs. Options range from user-friendly website builders like Shopify, Wix, and Squarespace, which offer e-commerce functionalities and customizable templates, to marketplaces like Etsy or eBay, which cater specifically to antiques and collectibles. Consider factors such as ease of use, cost, customization options, and the specific features each platform offers, such as inventory management, payment processing, and analytics.

Design Your Store with Care: The design of your online store should reflect the unique character of your antique collection while

ensuring a seamless browsing experience for customers. Use high-quality images and detailed descriptions for each item to convey its history, condition, and value. Organize your inventory into categories or collections to make it easy for customers to navigate and find what they're looking for. Incorporating elements of your brand, such as your logo, color scheme, and messaging, will help create a cohesive and memorable shopping experience.

Optimize for Search Engines: SEO (Search Engine Optimization) is crucial for making your online store visible to potential customers. Use relevant keywords in your product titles, descriptions, and meta tags to improve your store's ranking in search engine results. Regularly updating your site with fresh content, such as blog posts about the world of antiques or the stories behind specific items, can also enhance your SEO efforts.

Implement Secure Payment Options: Offering a variety of secure payment options can make the purchasing process easier and more appealing for customers. Ensure your platform supports major credit cards, PayPal, and other payment methods, and clearly communicate your payment, shipping, and return policies to build trust with customers.

Focus on High-Quality Photography: Because customers can't physically inspect items online, high-quality photographs are essential. Take multiple, well-lit photos of each item from various

angles, showing any unique features or flaws to provide a comprehensive view. Consider including a common object for scale or showcasing the item in a styled setting to give customers a better sense of its size and how it might look in their own space.

Engage with Your Customers: Use your online store and its associated social media platforms to engage with customers. Encourage questions, provide detailed responses, and share your expertise and passion for antiques. Customer reviews and testimonials can be featured prominently on your site to build credibility and attract new buyers.

Manage Your Inventory Carefully: Keep your online inventory updated to reflect current stock levels and avoid selling items that are no longer available. This includes promptly removing sold items and adding new acquisitions, along with updating descriptions and photos as needed.

Market Your Online Store: Promote your online store through various channels, including social media, email newsletters, and online advertising. Participating in online forums, blogs, and communities related to antiques can also help draw attention to your store.

Launching an online store for your antiques is not just about selling items; it's about creating a digital space that reflects the quality,

history, and passion behind your collection. By focusing on the customer experience, from discovery to purchase, you can build a successful online presence that complements your physical business and connects you with antique lovers worldwide.

Online Marketplaces for Antique Sales

Online marketplaces have revolutionized the way antiques are bought and sold, offering antique dealers and collectors access to a global audience. These platforms vary in focus, size, and audience, but each provides unique opportunities for showcasing and selling antique items. Here's an overview of some key online marketplaces for antique sales, highlighting their features and how they cater to the antique and vintage market:

eBay: eBay is one of the largest and most well-known online marketplaces, offering a vast audience for antique dealers. It's an auction-based platform that also allows for fixed-price listings, making it suitable for selling a wide range of antiques and collectibles. eBay's international reach can open up your items to buyers around the world. However, the vastness of the platform means competition can be stiff, and fees can add up.

Etsy: Etsy has carved out a niche for itself as a marketplace for handmade, vintage, and unique goods, including antiques. Its focus on craftsmanship and uniqueness makes it an ideal platform for dealers of vintage and antique items with a story. Etsy's user-friendly interface and supportive community atmosphere make it appealing to both sellers and buyers, though it charges listing and transaction fees.

1stdibs: Catering to the high-end antique, art, and vintage market, 1stdibs is known for its curated selection of items from reputable dealers worldwide. It's an excellent platform for selling rare and valuable antiques to discerning collectors and interior designers. Listing on 1stdibs requires approval, and the fees are higher, but it offers access to a premium market.

Ruby Lane: Ruby Lane specializes in antiques, art, vintage collectibles, and jewelry. It's known for its selective approach, ensuring a high-quality offering for buyers. The site fosters a community feel, appealing to serious collectors and antique enthusiasts. Ruby Lane charges a setup fee, monthly maintenance fees, and service fees, but it provides a targeted audience for antique sales.

Chairish: Chairish is an online marketplace focused on vintage and antique furniture, decor, art, and jewelry. It offers a curated selection, making it a favorite among interior designers and home

decor enthusiasts. Chairish provides a user-friendly platform for sellers and handles shipping logistics for larger items, which can be a significant advantage. However, it takes a commission on sales.

Facebook Marketplace and Groups: Facebook Marketplace and various antique-related groups on Facebook offer platforms for selling antiques locally and internationally. While not exclusively focused on antiques, the broad reach and lack of listing fees make it an attractive option for dealers. Selling through Facebook requires managing your transactions and shipping, but it allows for direct interaction with buyers.

Instagram: Though not a marketplace in the traditional sense, Instagram has become a vital platform for antique dealers to showcase their items and make sales through posts and stories. Its visual focus is perfect for highlighting the beauty and uniqueness of antique items. Sales typically happen through direct messages, making it a more informal but highly effective way to reach potential buyers.

When choosing an online marketplace for selling antiques, consider the type of items you're selling, the audience you want to reach, and the level of support and features you need. Each platform has its strengths and fee structures, so it's worth exploring multiple options

to find the best fit for your business. Additionally, maintaining a presence on several platforms can maximize your visibility and sales potential in the diverse and expanding online antique market.

Digital Marketing Strategies for Online Sales

Digital marketing strategies for online sales in the antiques industry must be crafted carefully to attract the right audience—those who appreciate the value, history, and uniqueness of antique items. The digital landscape offers a plethora of tools and platforms to reach potential buyers, but using them effectively requires a blend of creativity, precision, and strategic planning. Here's how to deploy digital marketing strategies to boost your online sales of antiques.

Content Marketing: Content is king in the digital world, and for antiques, it's the storytelling that sells. Create compelling content that tells the stories behind your pieces, delves into their historical context, or offers insights into antique collection and care. Blogs, videos, and podcasts can engage your audience, build your brand's authority, and drive traffic to your website or online store.

SEO (Search Engine Optimization): Optimizing your website for search engines is crucial to increase visibility and attract organic

traffic. Use keywords relevant to your antiques, such as the periods, styles, and types of items you offer, in your website's content, titles, and meta descriptions. Also, consider local SEO strategies if you have a physical store or focus on a specific geographical market.

Social Media Marketing: Platforms like Instagram, Pinterest, and Facebook are ideal for showcasing the visual appeal of antiques. Regular posts featuring high-quality images of your items, along with stories about their origins or restoration processes, can captivate an audience. Engage with your followers through comments, shares, and direct messages to build a community around your brand.

Email Marketing: Email remains a powerful tool for direct communication with your customers. Collect email addresses through your website, social media channels, or at physical sales events. Send regular newsletters that highlight new acquisitions, share exclusive offers, or provide valuable content related to antiques. Personalization and segmentation of your email list can increase the relevance and effectiveness of your campaigns.

Paid Advertising: Invest in paid advertising to reach a broader audience. Google Ads can drive traffic to your website, while Facebook and Instagram ads can increase your visibility on those

platforms. Target your ads based on interests, demographics, and behavior to reach potential buyers who are likely to be interested in antiques.

Influencer Partnerships: Collaborating with influencers in the antiques, vintage, or interior design spaces can introduce your brand to their followers. Choose influencers whose aesthetic and audience align with your brand, and work together on sponsored posts, giveaways, or content collaborations.

Online Marketplaces: Beyond your website, leverage online marketplaces like Etsy, eBay, or 1stdibs to sell your items. Each platform has its own audience and marketing tools. Utilize these marketplaces' promotional features, such as featured listings or ads, to increase the visibility of your items.

Analytics and Feedback: Use analytics tools to track the performance of your digital marketing efforts. Analyze website traffic, engagement rates on social media, email open rates, and sales data to understand what's working and what's not. Collecting feedback directly from your customers can also provide valuable insights into their preferences and how you can improve your marketing strategies.

Customer Experience: Enhancing the online customer experience can also be a powerful marketing strategy. Ensure your website is user-friendly, your product listings are detailed and accurate, and the purchasing process is seamless. Excellent customer service, including prompt responses to inquiries and efficient handling of any issues, can lead to positive reviews and word-of-mouth recommendations.

Implementing these digital marketing strategies requires ongoing effort and adaptation to changes in technology, consumer behavior, and the antiques market. However, by effectively leveraging these tools, antique dealers can significantly increase their online sales and build a strong, loyal customer base in the digital age.

Managing Online Customer Service

Managing online customer service effectively is crucial in the digital age, especially for businesses dealing in antiques, where trust and credibility are paramount. The unique nature of antiques each with its own history and nuances means that customers often require more information, reassurance, and personalized attention than they might with new, off-the-shelf products. Here's how to ensure your online customer service is up to the task, enhancing the customer experience and building lasting relationships:

Be Accessible: Provide clear and multiple channels for customers to reach out with inquiries or issues. This could include email, social media, live chat, and a contact form on your website. Make your contact information easy to find and respond to inquiries promptly to demonstrate that customer service is a priority for your business.

Offer Detailed Product Descriptions: Online customers can't physically examine items, so your product descriptions need to work hard. Provide detailed, accurate descriptions including the item's age, dimensions, condition, any restoration work, and historical significance. High-quality photos from multiple angles are also essential. This level of detail can reduce the number of queries and potential dissatisfaction.

Use FAQs and Knowledge Bases: An FAQ section or an online knowledge base can be invaluable. Include answers to common questions about shipping, returns, item care, and any other relevant topics. This empowers customers to find information themselves and can reduce the volume of straightforward inquiries, allowing you to focus on more complex questions.

Personalize the Service Experience: Personalization can make a significant difference in customer satisfaction. Use customer data responsibly to tailor your interactions based on previous purchases, inquiries, and preferences. Addressing customers by name and

referencing past interactions can make them feel valued and enhance their loyalty to your brand.

Implement Live Chat: Live chat offers immediate assistance, making it a powerful tool for enhancing online customer service. Customers can get quick answers to questions while browsing, which can encourage them to make a purchase. If offering 24/7 live chat isn't feasible, consider using chatbots to handle common queries outside of business hours.

Manage Complaints and Negative Feedback Effectively: When dealing with complaints or negative feedback, respond swiftly and with empathy. View these situations as opportunities to demonstrate your commitment to customer satisfaction. Offer fair solutions and follow up to ensure the issue has been resolved to the customer's satisfaction. Handling complaints well can turn dissatisfied customers into advocates for your business.

Solicit and Act on Customer Feedback: Regularly ask for feedback on your products and the shopping experience. You can do this through follow-up emails, surveys, or direct communication. Acting on this feedback not only improves your service but also shows customers that their opinions are valued and taken seriously.

Train Your Team: If you have a team, ensure they are trained in the specifics of your products and in customer service best practices.

They should understand the importance of empathy, patience, and clear communication. Regular training updates can help maintain high service standards.

Use Social Media Strategically: Social media platforms are not just for marketing; they're also important channels for customer service. Monitor your social media for questions, comments, and direct messages, and respond promptly. Public interactions on social media can showcase your commitment to customer service to a wider audience.

Offer Comprehensive After-Sale Support: After a sale, provide customers with detailed information about shipping, including tracking numbers and expected delivery times. Offer guidance on caring for their antique item and make it clear that you're available for any post-purchase questions.

Managing Your Inventory

Managing inventory is a critical aspect of running a successful antique business, whether it's a physical shop, an online store, or a combination of both. Effective inventory management involves not just keeping track of what items you have but also understanding their historical significance, condition, and value. It requires a strategic approach to buying, selling, and maintaining records to optimize your stock levels, ensure the diversity and quality of your collection, and meet customer demand.

The first step in managing your inventory is to develop a system for cataloging each item as it comes into your possession. This system should include detailed descriptions of the items, including their age, provenance, condition, any restorations or repairs they have undergone, and their purchase and potential sale prices. High-quality photographs are also essential, serving as a visual record and a tool for online sales. Utilizing inventory management software can streamline this process, allowing you to keep digital records that are easily searchable and updateable.

Regularly reviewing your inventory is crucial to understand what items you have, their current market value, and how long they have been in your stock. This review can help identify which items may need to be discounted to move, which are in high demand, and gaps

in your collection that you might want to fill. It also informs purchasing decisions, helping you buy smarter based on what sells well and what aligns with emerging trends.

Condition monitoring is an ongoing part of inventory management in the antique business. Regular checks can help identify any deterioration or damage early, allowing for timely conservation or restoration work to preserve the item's value. This is especially important for fragile or high-value items that may require specific environmental conditions to maintain their condition.

Pricing strategy is another critical component of inventory management. Prices should reflect the item's age, rarity, condition, and the current market demand, and they should be reviewed regularly to ensure they remain competitive and fair. Flexible pricing, with room for negotiation, can also be a strategic tool to encourage sales, especially for items that have been in stock for a long time.

Inventory turnover is a key metric for assessing the health of your antique business. Items that turn over quickly are good indicators of what your customers are looking for, while slow-moving items may indicate a need for reevaluation—whether of the item's price, its display, or its fit with your target market. Strategies for improving turnover include rotating displays, running promotions, and leveraging online sales channels to reach a wider audience.

For businesses with both physical and online sales channels, inventory management also involves ensuring that items are listed accurately across all platforms and that sold items are promptly removed to prevent double-selling. Integration between your point-of-sale system and your online store can automate this process, reducing the risk of errors.

Effective inventory management also plays a role in customer service. Being able to quickly locate items and provide customers with detailed information about their history and condition enhances the buying experience and builds trust. For online customers, accurate inventory records ensure that what they see on your website or online store is what is actually available, preventing frustration and disappointment.

Managing your inventory in the antique business requires a careful balance of historical knowledge, market awareness, and strategic planning. By adopting effective cataloging practices, regularly reviewing stock, monitoring condition, adjusting pricing, and optimizing turnover, you can ensure that your inventory supports both the operational success of your business and the satisfaction of your customers.

Inventory Management Techniques

Effective inventory management is crucial for businesses, especially those in sectors like retail, manufacturing, and e-commerce, where products are directly sold to customers. Managing inventory efficiently can significantly impact a business's operational efficiency, customer satisfaction, and profitability. Here's a comprehensive look at various inventory management techniques that businesses employ to streamline operations and ensure product availability.

Just-in-Time (JIT) Inventory: This approach involves keeping inventory levels as low as possible, ordering only what's needed for the near-term production or sales. JIT reduces the costs associated with holding and storing inventory, freeing up resources for other uses. However, it requires precise coordination with suppliers to ensure timely delivery of materials, making it vulnerable to disruptions in the supply chain.

ABC Analysis: This technique categorizes inventory into three groups based on its value and turnover rate. 'A' items are high-value products with a low sales frequency, 'B' items are moderate in value and sales frequency, and 'C' items are low-value but high-frequency sales products. This prioritization helps businesses focus their

resources and attention on managing the most important items more closely.

First-In, First-Out (FIFO): In the FIFO method, the oldest inventory items are sold first, ensuring that items on the shelf are always the newest. This technique is particularly useful for perishable goods or products with an expiration date, reducing the risk of obsolete inventory.

Last-In, First-Out (LIFO): Opposite to FIFO, LIFO involves selling the most recently produced or acquired items first. While LIFO can be beneficial for tax purposes in some jurisdictions, it may not be suitable for all types of inventory, especially those that can become outdated or spoil.

Economic Order Quantity (EOQ): EOQ is a formula used to determine the optimal order quantity that minimizes the total costs associated with ordering and holding inventory. This method requires an understanding of the fixed costs per order, the demand rate, and the carrying cost per unit per period. It's a valuable tool for reducing overall inventory costs.

Safety Stock Inventory: Keeping safety stock involves maintaining a predetermined level of extra stock to prevent stock-outs caused by fluctuations in demand or supply chain delays. While this technique

can increase storage costs, it ensures that businesses can meet customer demand without interruption.

Dropshipping: This inventory management strategy allows businesses to sell products without keeping them in stock. Instead, when a sale is made, the product is purchased from a third party and shipped directly to the customer. Dropshipping eliminates the need for holding inventory, reducing storage and handling costs.

Cross-Docking: In the cross-docking system, incoming shipments are directly transferred from the receiving dock to the outbound shipping dock, bypassing the need for long-term storage. This technique can reduce storage costs and speed up the delivery process but requires precise coordination and timing.

Inventory Turnover Analysis: Regular analysis of inventory turnover, or how quickly inventory is sold and replaced over a certain period, can provide insights into sales effectiveness and inventory management. High turnover indicates strong sales or effective inventory management, while low turnover may signal overstocking or declining sales.

Cycle Counting: Instead of a full inventory count at once, cycle counting audits inventory in small portions on a continuous basis. This method can reduce disruptions to operations and allow for more frequent checks on inventory accuracy.

Incorporating these inventory management techniques can help businesses optimize their operations, reduce costs, and improve customer satisfaction. The choice of technique(s) depends on the nature of the business, the types of products sold, and the specific challenges faced in managing inventory.

Tracking Your Stock and Sales

Tracking your stock and sales is a crucial component of managing your inventory, especially in businesses like antiques, where each item is unique and carries its own value and history. A robust system for tracking not only helps in maintaining an accurate record of what's in stock but also provides insights into sales trends, popular items, and customer preferences, allowing for informed decision-making. Here's a closer look at how to effectively track your stock and sales:

Implement an Inventory Management System: Utilizing inventory management software is key to efficiently tracking stock and sales. These systems can automate much of the process, from updating stock levels as sales occur to generating sales reports and identifying trends. Many software options are available, catering to

different sizes and types of businesses. Choose a system that fits your needs, considering factors like ease of use, scalability, integration with your sales platforms, and cost.

Use SKU Numbers: Assign a unique stock keeping unit (SKU) number to each item in your inventory. This practice is particularly important in the antique business, where each item is distinct. SKUs make it easier to track items through your inventory system, helping you quickly locate products in your records and monitor their sales status.

Regular Stock Audits: Conduct regular physical audits of your inventory to ensure the accuracy of your tracking system. This is especially important in a business dealing with unique items, where discrepancies can arise due to data entry errors, items being misplaced, or other issues. Regular audits help identify and correct these discrepancies, maintaining the integrity of your inventory records.

Monitor Sales Trends: Your inventory management system should allow you to monitor sales trends, such as which items are selling quickly, which are slow-moving, and at what times of year certain items tend to sell. This information is invaluable for making purchasing decisions, setting pricing strategies, and planning for seasonal variations in demand.

Track Customer Preferences: In addition to tracking which items sell, note who buys them and any feedback received. This data can help you understand your customer base better, tailor your stock to match their preferences, and even personalize your marketing efforts.

Manage Online and Offline Sales Together: If you sell both in a physical location and online, it's essential to integrate these sales channels in your inventory tracking. This ensures that your stock levels are updated in real time, regardless of where a sale is made, preventing overselling items or stock discrepancies between channels.

Set Reorder Points: For businesses that deal in reproductions or antique items that can be sourced consistently, setting reorder points for your inventory is a useful technique. A reorder point is the stock level at which you need to order more of an item. Although this technique might be less applicable to unique antiques, it can be useful for related products or supplies.

Leverage Data for Purchasing Decisions: Use the data from your inventory and sales tracking to inform your purchasing decisions. Knowing which items sell well and which don't can guide you in

curating your future inventory, ensuring you invest in pieces that are more likely to sell.

Backup Your Data: Ensure that all your inventory and sales data is regularly backed up. This is crucial for protecting your business against data loss due to technical issues or other unforeseen problems. Most inventory management systems offer cloud-based backups, but it's good practice to have an additional backup system in place.

Effectively tracking your stock and sales is not just about keeping accurate records; it's about using the insights gained from this data to make strategic decisions that improve the efficiency and profitability of your business. By implementing a robust inventory management system, regularly auditing your stock, and analyzing sales trends, you can enhance your inventory management practices and better meet the needs of your customers.

Balancing Your Inventory Mix

Balancing your inventory mix in the antique business is an artful endeavor that requires a strategic approach to cater to diverse customer interests while maintaining the uniqueness and authenticity that define your offerings. A well-balanced inventory can attract a wider audience, encourage repeat visits, and increase sales. Here's how to achieve a harmonious balance in your antique inventory:

Understand Your Customer Base: Start by analyzing your existing customer base and market demand. Who are your customers, and what are they looking for? Understanding the preferences, spending habits, and collecting interests of your audience is crucial. This knowledge helps in curating an inventory that appeals directly to their tastes while also introducing them to new finds that complement their existing interests.

Diversify Your Offerings: Aim for diversity in your inventory to appeal to a broad range of customers. This can mean stocking items from various periods, styles, and price points. However, diversity should not come at the expense of your brand's identity. Ensure that even within this variety, your offerings resonate with the overarching theme or niche that defines your business. For example, if your focus is on Victorian-era antiques, you might include

furniture, decorative items, and textiles from that period but in a range of prices and conditions.

Monitor Trends and Adapt: Stay informed about current trends in the antiques market as well as broader interior design and lifestyle trends. This awareness can guide you in adjusting your inventory to include items that are currently in demand or rising in popularity. However, while it's important to adapt to trends, your inventory should also maintain a timeless appeal that transcends fleeting fashions.

Balance Investment Pieces with More Accessible Finds: Include a mix of high-value investment pieces and more affordable finds in your inventory. While the high-value items may attract serious collectors and potentially offer higher margins, the more accessible items can drive regular sales and cater to casual buyers or those just starting their collections. This balance ensures that your business can cater to both ends of the market spectrum.

Rotate and Refresh Your Inventory Regularly: Regularly rotating your stock keeps your inventory fresh and engaging for repeat customers. Highlight new acquisitions in your marketing efforts to pique interest and draw customers back to see what's new. This practice not only sustains customer interest but also allows you to experiment with different types of items to see what resonates with your audience.

Manage Inventory Levels Strategically: While variety is important, it's also crucial to manage the quantity of stock to avoid over accumulation of hard-to-sell items. Regularly review your inventory to identify slow-moving items and consider markdowns, auctions, or selling them to other dealers to free up space and capital for new acquisitions.

Leverage Data for Inventory Decisions: Use sales data, customer feedback, and market research to make informed decisions about your inventory mix. Analyzing which items sell quickly versus those that linger can provide valuable insights into customer preferences and market trends, helping you refine your inventory strategy over time.

Cultivate a Unique Selection: In the antiques business, uniqueness sells. Strive to offer items that customers can't find elsewhere easily. This could mean focusing on rare finds, pieces with exceptional provenance, or items that showcase exceptional craftsmanship. A unique inventory can become your business's hallmark, distinguishing you from competitors and making your store or booth a must-visit for enthusiasts and collectors.

Financial Management

Financial management is a cornerstone of running a successful antique business, involving careful planning, monitoring, and controlling of financial resources to achieve your business objectives. Given the unique nature of the antique market, with its fluctuations in demand and the diverse value of inventory, effective financial management becomes even more critical. Here's an in-depth look at navigating the financial aspects of an antique business:

Understanding Cash Flow: Cash flow—the amount of money flowing in and out of your business—dictates your operational viability. Antique businesses, in particular, need to manage cash flow carefully due to the sometimes unpredictable nature of sales and the need to invest in inventory upfront. Regularly monitor your cash flow to ensure you have enough liquidity to cover operating expenses, including acquisitions, restoration, rent, utilities, and payroll. Tools like cash flow statements and forecasts can help you anticipate fluctuations and plan accordingly.

Budgeting and Forecasting: Creating a detailed budget is essential for tracking and controlling your finances. Your budget should account for fixed costs (like rent and salaries), variable costs (such as inventory purchases and restoration expenses), and unexpected costs. Use historical sales data and market trends to forecast revenue and adjust your budget as needed. Regularly comparing actual expenses and income against your budget allows you to identify discrepancies and make adjustments.

Pricing Strategy: Pricing antiques correctly is crucial for profitability. Your prices should reflect the item's rarity, condition, provenance, and the current market demand, while also covering your costs and providing a reasonable margin. Regularly review your pricing strategy in light of sales data, market trends, and acquisition costs to ensure it remains competitive and profitable.

Inventory Management: Efficient inventory management is vital for maintaining a healthy balance between invested capital and sales. Keep detailed records of your inventory, including acquisition costs, restoration expenses, and sales prices. This not only aids in pricing and sales strategies but also in insurance and tax preparations. Consider implementing inventory management software tailored to the nuances of the antique market.

Tax Planning and Compliance: Understanding your tax obligations and planning accordingly can save you significant money and prevent legal issues. This includes income tax, sales tax, and any other relevant taxes. Keep meticulous records of all transactions, expenses, and income. Consider consulting with a tax advisor who understands the specifics of the antique business to ensure compliance and take advantage of any applicable deductions or tax-saving strategies.

Investing in Growth: Financial management also involves making strategic decisions about reinvesting profits into your business. This could mean expanding your inventory, investing in marketing to reach new customers, or upgrading your physical or online storefronts. Carefully weigh the potential return on these investments against the risk and cost.

Risk Management: The antique business comes with inherent risks, from fluctuating market demand to the potential for damage or loss of inventory. Diversifying your inventory, investing in security measures, obtaining appropriate insurance, and setting aside financial reserves can help mitigate these risks and protect your business's financial health.

Adapting to Change: The antique market can be influenced by economic factors, trends, and changing consumer preferences. Staying informed about the market and being willing to adapt your business model, whether through diversifying your product range or exploring new sales channels, can help maintain financial stability in a changing landscape.

Setting Up and Managing Your Budget

Setting up and managing a budget is an essential task for any business owner, including those in the antique industry. A well-planned budget serves as a roadmap for your business, guiding financial decisions and helping to ensure sustainability and growth. The process involves estimating your revenue, calculating expenses, and planning for both expected and unexpected financial needs.

Start by examining your revenue streams. In the antique business, this might include direct sales from a physical store or booth, online sales, and perhaps services such as appraisals or restoration. Historical sales data can provide a baseline, but you should also consider market trends, seasonal fluctuations, and potential new revenue opportunities. Being realistic and somewhat conservative in

your revenue estimates can help you avoid overly optimistic spending plans.

Next, list your expenses, which typically fall into two categories: fixed and variable. Fixed expenses, such as rent for your store or booth space, utilities, insurance, and salaries, remain relatively constant regardless of sales volume. Variable expenses, including inventory purchases, marketing costs, restoration expenses, and shipping, fluctuate based on the level of business activity and decisions you make about where to invest resources.

After identifying your revenue and expenses, subtract the total expenses from the total expected revenue to determine your budgetary baseline. This figure can indicate your potential profit margin and provide insight into how much you can afford to invest in inventory expansion, marketing efforts, or other growth strategies.

Effective budget management also requires regular monitoring and adjustment. Set up a system for tracking actual revenue and expenses against your budgeted amounts. This can be done through accounting software, spreadsheets, or financial management apps. Regularly reviewing this data allows you to identify trends, such as increasing costs or underperforming sales channels, and adjust your spending or strategies accordingly.

Contingency planning is another critical aspect of budget management. Anticipate potential financial challenges, such as unexpected drops in sales, increases in costs, or emergency expenses, and allocate a portion of your budget to a contingency fund. This can provide a financial cushion that helps you navigate unforeseen circumstances without jeopardizing the overall health of your business.

In addition to these practical steps, effective budget management in the antique business also involves strategic thinking about how to maximize the value of your inventory. This might include focusing on higher-margin items, exploring new markets or sales channels, and developing a network of suppliers to secure the best possible prices for inventory purchases.

Consider seeking advice from financial advisors or mentors who can provide insights based on their experience and expertise. They can offer guidance on common financial pitfalls in the antique business and strategies for effective budget management.

Financial Planning and Forecasting

Financial planning and forecasting are vital processes that help antique business owners make informed decisions about the future. These processes involve estimating future revenues, costs, and financial performance based on historical data, market trends, and strategic planning. By anticipating future financial conditions and results, you can set realistic goals, allocate resources more effectively, and manage risks, ensuring the sustainability and growth of your business.

Understanding Financial Planning

Financial planning starts with defining your business goals and objectives, both short-term and long-term. This could range from expanding your inventory to include a new category of antiques, increasing online sales, or opening a new physical location. Once goals are set, the next step is to create a comprehensive plan that outlines how to achieve these objectives. This includes budgeting, setting sales targets, planning inventory purchases, marketing activities, and any capital investments needed.

A crucial aspect of financial planning is assessing your financial health, including analyzing your cash flow, profit margins, and debt levels. This assessment provides a clear picture of where your business stands and what actions are needed to reach your financial

goals. Effective financial planning also involves regular reviews and adjustments to ensure that your strategies remain aligned with changing market conditions and business realities.

The Role of Financial Forecasting

Financial forecasting extends the financial planning process into the future. It involves using historical financial data and market analysis to predict future financial outcomes. These forecasts help you anticipate sales trends, cash flow patterns, and the impact of external factors such as economic shifts or changes in consumer behavior.

Short-term forecasts might cover the next quarter or year, focusing on detailed revenue and expense predictions. These are particularly useful for managing cash flow and ensuring you can cover upcoming expenses. Long-term forecasts, on the other hand, might extend five or ten years into the future, helping in strategic planning, such as for business expansion or major investments.

Techniques and Tools

Several techniques can be used for financial planning and forecasting. The most common include:

Historical Analysis: Examining past financial performance to identify trends and patterns that are likely to continue.

Comparative Analysis: Comparing your business's financial metrics to industry benchmarks or competitors to identify opportunities for improvement.

Cash Flow Forecasting: Estimating the flow of cash in and out of your business to ensure you have sufficient liquidity to meet your obligations.

Scenario Planning: Creating different forecasts based on various scenarios, such as best case, worst case, and most likely case, to prepare for different possibilities.

Technology plays a crucial role in financial planning and forecasting. Many software solutions are available that can automate data collection, perform complex analyses, and generate detailed financial reports and forecasts. These tools can save time, reduce errors, and provide deeper insights into your business's financial future.

Integrating Financial Planning and Forecasting into Decision Making

Integrating the insights gained from financial planning and forecasting into your decision-making process is essential. This might involve making strategic investments, adjusting pricing strategies, expanding or reducing inventory, or even changing marketing tactics. Regularly reviewing your financial plans and

forecasts, and comparing actual performance against these benchmarks, allows you to adjust your strategies in real-time, keeping your business on track towards achieving its goals.

Profit Maximization Strategies

Profit maximization is the process of identifying and implementing strategies to increase the net profits of a business, considering both short-term gains and long-term sustainability. For antique dealers and businesses in the antiques market, profit maximization involves not just selling items at a higher price but also optimizing every aspect of the operation to reduce costs, enhance customer satisfaction, and increase sales volumes. Here's how you can apply profit maximization strategies effectively in the antique business.

Optimize Pricing Strategy: Your pricing strategy should reflect the unique value and history of each antique, as well as market demand and the item's condition. Utilize pricing models that consider acquisition costs, restoration expenses, and comparative market analysis. Dynamic pricing, where prices are adjusted based on demand, rarity, and market trends, can also help maximize profits.

Improve Inventory Turnover: Fast-moving inventory generates more revenue and reduces holding costs. To improve inventory turnover, focus on items with higher demand, consider special promotions for slow-moving items, and continuously refresh your collection to draw in customers. Utilizing sales data and market trends helps in making informed decisions about which items to stock.

Expand Your Customer Base: Reaching new customers can significantly boost your sales and profits. Expand your online presence through social media, online marketplaces, and an engaging website. Collaborate with interior designers, event planners, and other professionals who can introduce your pieces to their clients. Participating in antique shows and fairs also increases visibility to a wider audience.

Enhance Customer Experience: A satisfied customer is more likely to make a purchase and return in the future. Improve the customer experience by offering exceptional knowledge and service, creating an inviting store or booth setup, and providing personalized recommendations. Building customer loyalty through rewards programs or exclusive offers can also encourage repeat business and referrals.

Reduce Costs: Identify areas where you can reduce costs without compromising the quality of your inventory or customer service. This could involve negotiating better terms with suppliers, optimizing restoration processes, or reducing overhead by managing inventory storage efficiently. Regularly review your expenses to identify cost-saving opportunities.

Leverage Technology: Implementing the right technology can streamline operations, reduce manual labor, and enhance the customer shopping experience. Inventory management software, customer relationship management (CRM) systems, and e-commerce platforms can improve efficiency and sales, contributing to profit maximization.

Diversify Revenue Streams: Look beyond direct sales for profit opportunities. Offering appraisal services, restoration work, or hosting workshops and events can provide additional revenue streams. Selling complementary items, such as antique care products or related memorabilia, can also increase average transaction values.

Analyze and Adjust: Continuously monitor your business performance using key financial metrics such as gross margin, net profit margin, and return on investment. Analyze sales data to understand what's working and where there's room for improvement. Being willing to adjust your strategies based on

performance data and market changes is crucial for long-term profit maximization.

Focus on Quality and Authenticity: In the antiques market, the authenticity and condition of items significantly affect their value. Focusing on quality pieces and ensuring their authenticity through rigorous provenance checks can command higher prices and attract discerning customers willing to pay a premium for guaranteed authenticity.

Profit maximization in the antique business requires a multifaceted approach, blending traditional business strategies with the unique aspects of the antiques market. By focusing on optimizing pricing, improving inventory turnover, expanding your customer base, enhancing customer experience, and leveraging technology, you can increase your profits while fostering sustainable growth and customer loyalty.

Handling Cash Flow Challenges

Handling cash flow challenges is a critical aspect of managing any business, including those in the antiques sector where sales can be unpredictable and inventory costs high. Cash flow, essentially the net amount of cash being transferred into and out of a business, directly impacts its ability to operate effectively, invest in new inventory, and grow. Here are strategies to navigate and overcome cash flow challenges, ensuring the sustainability and success of your antique business.

Regular Cash Flow Monitoring: The first step in managing cash flow challenges is to keep a close eye on your cash flow. This involves regularly updating and reviewing cash flow statements to identify patterns, such as seasonal fluctuations in sales or periods of tight liquidity. By understanding your cash flow cycle, you can anticipate challenges and take proactive measures.

Improving Receivables: Accelerating the inflow of cash from sales is crucial. For businesses that sell on credit, consider implementing strategies such as offering discounts for early payments, requiring deposits on high-value items, or using invoice financing services. For direct sales, streamline the payment process to make it as easy as possible for customers to pay immediately and securely, whether in-person or online.

Managing Payables: While it's important to meet your obligations, managing when and how you pay your bills can ease cash flow pressures. Negotiate with suppliers for extended payment terms or discounts for early payment. Prioritize payments based on their urgency and the potential for late fees, keeping communication open with suppliers about your payment plans.

Inventory Management: Inventory is a significant investment for antique dealers. Optimize your inventory levels to balance having a diverse and attractive selection with minimizing costs tied up in stock. Regularly review your inventory to identify slow-moving items and consider discounts or promotions to convert them into cash. Additionally, investing in items with a quicker turnover can help maintain a healthier cash flow.

Contingency Planning: Having a contingency plan for unexpected cash flow challenges is essential. This could include establishing a line of credit that can be accessed when needed, setting aside reserves during more profitable periods, or identifying non-core assets that could be sold off in a pinch.

Cost Control: Regularly review and control your operating expenses. Identify areas where you can cut costs without compromising the quality of your inventory or customer experience. This might involve renegotiating rent, reducing utility costs, or finding more cost-effective marketing channels.

Diversification: Diversifying your sales channels can help stabilize cash flow. In addition to your physical store or booth, consider selling online through your website or online marketplaces, participating in antique shows, or leveraging social media platforms. Each channel can provide different cash flow dynamics, with online sales often resulting in quicker payments.

Leverage Financing Options: In times of cash flow shortages, financing options such as business loans, lines of credit, or merchant cash advances can provide the necessary capital to bridge the gap. However, it's important to carefully consider the terms and costs associated with these options to ensure they're sustainable for your business in the long term.

Customer Engagement and Loyalty Programs: Engaging with your customers and encouraging repeat business can lead to more consistent sales. Implement loyalty programs, customer appreciation events, or exclusive previews of new collections to keep your customers coming back.

Handling cash flow challenges requires a mix of proactive management, strategic planning, and sometimes creative financing solutions. By staying vigilant about your cash flow, cutting costs judiciously, and exploring new sales avenues, you can navigate the ups and downs of the antique business and set the stage for long-term success.

Expanding Your Business

Expanding your business is a significant milestone that comes with both excitement and challenges. For antique dealers, expansion can mean diversifying inventory, extending the customer base, opening new locations, or enhancing online sales channels. Careful planning, market research, and strategic execution are crucial to successfully grow your business while maintaining its unique character and customer service standards.

Understanding Market Demand: Before embarking on expansion, it's essential to understand the current market demand for antiques and collectibles. This involves researching trends within the antique world, identifying gaps in the market, and assessing customer needs and preferences. Market demand can guide you on which areas of your business are ripe for expansion and where there's potential to introduce new categories or services.

Diversifying Inventory: Expanding your range of inventory can attract a broader customer base and meet the varied interests of current customers. Consider exploring new categories of antiques, such as vintage fashion, rare books, or specific periods of furniture, that complement your existing offerings. Diversification should be based on thorough research to ensure there's a market for these new items and that they align with your brand's identity.

Enhancing Online Presence: In today's digital age, strengthening your online sales channels can significantly boost your business expansion. This might involve revamping your website, optimizing it for search engines, and offering an online purchasing option if you haven't already. Expanding your reach through social media platforms, online marketplaces, and digital marketing strategies can also drive online sales and introduce your business to customers worldwide.

Opening New Locations: For some, business expansion might mean opening new physical locations. This could be in the form of additional booths in antique malls, pop-up shops in different cities, or a standalone store. The decision to open new locations should be based on careful analysis of location, foot traffic, local market demand, and financial feasibility. Each new location should maintain the unique atmosphere and customer service quality that defines your business.

Building Partnerships and Collaborations: Collaborating with other businesses, interior designers, event planners, or online influencers can open new avenues for expansion. These partnerships can introduce your inventory to new audiences, offer cross-promotional opportunities, and even lead to exclusive deals or events that enhance your business's profile.

Investing in Marketing: As you expand, investing in marketing becomes even more critical to attract new customers and retain existing ones. Tailor your marketing strategies to target specific audiences, highlighting the unique value and stories behind your inventory. Employing a mix of traditional and digital marketing tactics can maximize your reach and impact.

Training and Hiring Staff: Expansion often requires bringing on additional staff or training current employees to manage increased operational demands. It's vital to maintain a team that shares your passion for antiques and commitment to customer service. Investing in training ensures that your staff can deliver the knowledge and service that customers expect, even as your business grows.

Financial Management: Successful expansion requires robust financial planning to manage increased costs and investments. This includes budgeting for inventory purchases, marketing, staffing, and any new locations or renovations. Monitoring cash flow and securing financing, if needed, are also crucial to sustain growth phases.

Adapting to Change: As your business expands, staying adaptable is key. The market for antiques can change, and what works in one location or online platform may not work in another. Regularly review your expansion strategies, be open to customer feedback, and be willing to adjust your approach as needed.

Expanding your antique business requires a delicate balance between seizing new opportunities and preserving the essence of what makes your business special. By carefully planning your expansion, understanding your market, and staying true to your brand, you can grow your business while continuing to offer unique and cherished items to a wider audience of collectors and enthusiasts.

Growth Strategies for Antique Booth Businesses

Growth strategies for antique booth businesses require a combination of creative merchandising, strategic planning, and targeted marketing. As each booth operates within a unique niche of the broader antiques market, tailoring growth strategies to align with specific business goals and customer preferences is essential. Here's an exploration of strategies designed to expand your antique booth business effectively.

Expand Your Inventory Range: Diversification is key to attracting a broader audience. Consider incorporating items from different eras, styles, or categories that complement your existing inventory. This not only caters to a wider range of tastes but also encourages existing customers to spend more time exploring your booth. However,

ensure that any new additions align with your booth's overall theme and quality standards to maintain a cohesive shopping experience.

Improve Booth Presentation: The visual appeal of your booth plays a significant role in attracting customers. Invest in attractive, thematic display fixtures that enhance the visual impact of your items. Use lighting effectively to highlight key pieces and create a welcoming atmosphere. Regularly refreshing your booth layout and decor can also keep the space engaging for repeat visitors.

Leverage Digital Marketing: Establishing an online presence can significantly enhance your booth's visibility. Use social media platforms to showcase your inventory, share stories about unique pieces, and announce new arrivals or special promotions. An engaging online presence can draw more visitors to your physical booth and help build a loyal customer base. Consider also creating an online store to complement your booth, offering another channel for sales.

Participate in Antique Shows and Fairs: Beyond your regular booth location, participating in antique shows and fairs can expose your business to a wider audience. These events are also excellent opportunities for networking with other dealers, which can lead to partnerships or sourcing opportunities. Be selective about the shows you attend, focusing on those that align with your inventory and target market.

Offer Additional Services: Expanding your service offerings can differentiate your booth from competitors. Consider offering appraisal services, restoration consultations, or interior design advice related to antiques. These services can add value to the customer experience, encourage repeat business, and generate additional revenue streams.

Build Customer Relationships: Developing strong relationships with your customers is crucial for repeat business. Personalize the shopping experience by remembering customer preferences, offering tailored recommendations, and keeping in touch through email newsletters or social media updates. Excellent customer service, including flexible return policies and knowledgeable staff, can also enhance customer loyalty.

Collaborate with Other Dealers: Collaboration can open new avenues for growth. Partnering with dealers who offer complementary items can lead to cross-promotional opportunities, shared booth space at events, or even joint purchasing agreements to secure better deals on inventory. Collaboration can extend your reach and introduce your booth to new customers.

Educate Your Audience: Positioning yourself as an expert in your niche can attract customers interested in learning more about antiques. Host workshops, lectures, or informal talks at your booth or in partnership with local community centers or historical

societies. Sharing your knowledge not only enriches the customer experience but also establishes your credibility and attracts enthusiasts.

Focus on Quality Over Quantity: While expanding your inventory can attract more customers, focusing on the quality and uniqueness of your items can foster a reputation for excellence that attracts discerning buyers. Carefully curate your selection to include pieces that stand out for their history, craftsmanship, or rarity.

Implementing these growth strategies requires careful planning and a commitment to maintaining the unique charm and quality that define your antique booth. By diversifying your inventory, enhancing your booth's appeal, leveraging digital tools, and building strong customer relationships, you can drive growth and ensure the long-term success of your antique booth business.

Exploring Additional Revenue Streams

Exploring additional revenue streams can significantly enhance the profitability and sustainability of an antique booth business. Diversification of income sources not only reduces reliance on direct sales but also maximizes the potential of your existing resources and customer base. Here are several strategies to consider for expanding your revenue streams in the antique business:

Offering Restoration and Repair Services: Many antique items require restoration or repair to return to their former glory. By offering these services, you can attract customers who own antiques and are looking to preserve or enhance their value. If you possess the skills required for restoration, this can be a lucrative addition to your business. Otherwise, partnering with skilled craftsmen and offering this service through your booth can also be beneficial.

Appraisal Services: Given your expertise in antiques, offering appraisal services can be a valuable revenue stream. Collectors, estate executors, and casual buyers often need professional appraisals for insurance purposes, estate planning, or sales. Hosting appraisal events or offering private consultations can attract new customers to your booth and establish your reputation as an expert in the field.

Conducting Workshops and Classes: There is a growing interest in antiques and vintage items, not just as collectibles but also for their historical and aesthetic value. Hosting workshops or classes on topics such as antique identification, history, restoration techniques, or how to start collecting can engage your existing customer base and attract new enthusiasts. These educational offerings can be a source of revenue while also enhancing the visibility of your business.

Online Sales: Expanding your sales channels to include online platforms can open up national and international markets for your antiques. Selling through your website, social media, or online marketplaces can significantly increase your reach. While online sales require additional management in terms of shipping and online customer service, the potential for increased sales can make this a worthwhile venture.

Rental Services: Antiques, especially larger items like furniture or decorative pieces, can be rented out for events, photo shoots, or film and theatre productions. This service provides customers with temporary access to unique items while generating additional income for your business. Establishing a rental agreement that includes security deposits, rental periods, and terms of use is essential for protecting your items.

Subscription Services: Create a subscription service where customers can receive curated selections of small antiques, vintage collectibles, or themed items on a regular basis. This model encourages repeat business and provides a steady income stream. Subscriptions can be tailored to different interest areas and price points to appeal to a broad range of customers.

Selling Related Products: In addition to antiques, consider selling related products that appeal to your customer base. This could include antique care products, such as polish or conservation supplies; books on antique collecting or history; or even vintage-inspired new items. These complementary products can enhance the shopping experience and add another layer of revenue.

Collaborations and Partnerships: Partner with local artists, craftsmen, or other businesses to offer exclusive products or services through your booth. This could include artist-designed decorative items that complement your antiques, joint events, or cross-promotions that benefit both parties. Collaborations can also increase your business's exposure and attract new customers.

Franchising or Opening Additional Locations

Expanding an antique business through franchising or opening additional locations offers a pathway to growth and increased brand presence. This strategic move, however, requires careful planning, a deep understanding of your business model, and an assessment of market demand. Here's a detailed exploration of both approaches to expansion:

Franchising Your Antique Business

Franchising involves allowing others to open their own stores under your brand name, using your business model and branding. This can significantly expand your business's reach without the need for you to manage each new location directly.

Develop a Strong Business Model: Before franchising, ensure your business model is successful, replicable, and appealing to potential franchisees. This includes having a recognizable brand, a clear value proposition, and a proven track record of profitability.

Create Franchise Documentation: Develop comprehensive franchise documentation, including an operations manual that details how to run the business, and a franchise agreement that outlines the terms and conditions of the franchise relationship.

Training and Support: Offering thorough training and ongoing support to your franchisees is crucial for maintaining the quality and consistency of your brand. This might include training on antique appraisal, customer service, inventory management, and marketing.

Legal Considerations: Franchising involves specific legal requirements, including the creation of a Franchise Disclosure Document (FDD) and compliance with state and federal franchising laws. Consulting with a lawyer experienced in franchising is essential.

Selecting Franchisees: Carefully select franchisees who share your passion for antiques and commitment to customer service. The success of your franchised locations depends largely on the dedication and competence of the franchisees.

Opening Additional Locations

Expanding by opening new locations yourself gives you more control over each store and ensures that all aspects of the business align with your vision and standards.

Market Research: Conduct thorough market research to identify potential locations. Look for markets with a demand for antiques but relatively low competition, considering factors like foot traffic, demographic trends, and local economic conditions.

Site Selection: Choose your new locations carefully, considering visibility, accessibility, and the character of the neighborhood. The right location can significantly impact the success of your new store.

Consistent Branding and Experience: Ensure that each new location reflects your brand's identity and provides a consistent customer experience. This includes interior design, quality of inventory, and level of customer service.

Operational Efficiency: Streamline operations across all locations to reduce costs and ensure consistency. This might involve centralized purchasing, shared marketing efforts, and standardized operating procedures.

Management and Staffing: Hiring and training the right managers and staff for each new location is crucial. Employees should be knowledgeable about antiques and aligned with your business's values and customer service philosophy.

Financial Planning: Opening new locations requires significant upfront investment. Prepare detailed financial projections to assess the feasibility of expansion and secure the necessary funding.

Whether through franchising or opening additional locations, expanding your antique business requires a strategic approach and careful execution. By ensuring the quality of your brand and operations, conducting thorough market research, and selecting the

right partners or locations, you can successfully grow your business and reach new customers.

Collaborations and Partnerships

Collaborations and partnerships can be transformative for antique businesses, offering novel avenues for growth, exposure, and diversification. In an industry where the provenance, story, and uniqueness of items play a significant role in their value, joining forces with other businesses, individuals, or organizations can enhance your offerings and attract new customer segments.

Here's a detailed exploration of how collaborations and partnerships can benefit your antique business:

Partnering with Interior Designers: Interior designers constantly seek unique, high-quality pieces to complete their projects. By establishing a partnership, you can become their go-to source for antiques, which can lead to consistent sales and exposure to their clientele. Consider offering trade discounts or exclusive viewing opportunities to strengthen this relationship.

Collaborating with Artists and Artisans: Teaming up with artists and artisans to create one-of-a-kind pieces can differentiate your inventory. For example, an artist could restore or repurpose vintage

items, infusing them with a contemporary appeal while preserving their historical essence. These collaborations can result in exclusive products that attract attention and command higher prices.

Cross-Promotions with Complementary Businesses: Identify businesses that share your target market but don't directly compete with you, such as vintage clothing stores, art galleries, or specialty coffee shops. Cross-promoting each other's offerings can expand your customer base. This could take the form of joint events, shared advertising, or featuring each other's products in your respective spaces.

Engaging with Historical Societies and Museums: Collaborations with historical societies, museums, or cultural organizations can lend credibility to your business and provide access to a broader audience interested in history and preservation. You could host educational events, sponsor exhibitions, or offer expert appraisals, establishing your business as a knowledgeable and engaged member of the community.

Participation in Antique Shows and Fairs: Joining forces with organizers of antique shows, fairs, or auctions can increase your visibility and sales opportunities. These events attract collectors and enthusiasts from various locations, providing a platform to showcase your best pieces. Building relationships with organizers can also secure favorable terms or prime booth locations.

Online Collaborations: In the digital realm, partnerships with influencers, bloggers, or websites dedicated to antiques, interior design, or history can amplify your online presence. These collaborations could involve sponsored content, social media takeovers, or affiliate marketing, reaching audiences that are already engaged and interested in related content.

Community Projects and Charity Events: Getting involved in community projects or charity events can not only contribute to a good cause but also raise your business's profile. Whether it's donating items for auction, hosting fundraising events, or offering your expertise for community restoration projects, these activities can foster goodwill and attract positive attention to your business.

Workshops and Educational Offerings: Collaborating with experts to offer workshops, lectures, or courses on topics related to antiques, such as history, restoration techniques, or collecting tips, can attract enthusiasts and novices alike. These educational offerings can position your business as a leader in the field and build a community of loyal customers and advocates.

Challenges and Solutions

In the dynamic world of antiques, businesses face unique challenges that require innovative and thoughtful solutions. The nature of dealing with rare, often one-of-a-kind items, coupled with shifting market trends and customer preferences, can present obstacles to growth and profitability. Here's a look at some common challenges in the antique business and strategies to address them:

Challenge: Fluctuating Market Demand

The demand for certain types of antiques can vary widely over time, influenced by changing trends, economic conditions, and generational shifts in taste.

Solution: Diversification of inventory can mitigate the risks associated with fluctuating demand. By offering a wide range of items from different periods, styles, and price points, you can appeal to a broader customer base. Staying informed about market trends and adapting your acquisition strategy accordingly can also help align your inventory with current demand.

Challenge: Authenticity and Provenance Verification

Ensuring the authenticity and provenance of antiques is crucial for maintaining credibility and trust with customers but can be challenging, especially for rare or highly valuable items.

Solution: Develop a network of trusted experts for authentication and invest in education and research tools to improve your ability to verify the authenticity and provenance of items. Providing detailed documentation and transparency about the authentication process to customers can also enhance trust and reduce the risk of disputes.

Challenge: Online Competition

The rise of online marketplaces and digital platforms has increased competition in the antiques sector, making it harder for traditional brick-and-mortar businesses to attract customers.

Solution: Embrace the online world by establishing a strong digital presence. This can include an e-commerce-enabled website, active social media profiles, and participation in online antique marketplaces. Offering unique online content, such as blogs or videos that share the stories behind your items, can differentiate your business and draw online traffic.

Challenge: Inventory Management

Managing a diverse and constantly changing inventory of unique items poses logistical challenges, from storage and documentation to pricing and sales tracking.

Solution: Implement a robust inventory management system tailored to the needs of the antique business. This can facilitate more accurate tracking of items, streamline pricing and sales processes, and improve overall operational efficiency. Regular inventory audits can also help maintain accurate records and identify opportunities to rotate stock or adjust pricing.

Challenge: Customer Acquisition and Retention

Attracting new customers and retaining existing ones in a niche market requires ongoing effort and innovative marketing strategies.

Solution: Leverage a mix of traditional and digital marketing tactics to reach a wider audience. This can include content marketing that highlights the uniqueness and history of your items, targeted social media advertising, email newsletters, and participation in antique shows and community events. Offering exceptional customer service and personalized shopping experiences can also enhance customer loyalty.

Challenge: Shipping and Handling of Fragile Items

Shipping antique items, especially fragile or large pieces, presents risks of damage and adds logistical complexity.

Solution: Develop expertise in packaging and shipping antiques, using materials and techniques that ensure items are protected during transit. Offering insured shipping options and working with reliable shipping partners can reduce risk. For larger items, consider local delivery services or encouraging local pickup.

Challenge: Maintaining Profitability

The cost of acquiring, restoring, and maintaining inventory, coupled with operational expenses, can challenge profitability, especially in a market where customers are looking for deals.

Solution: Focus on cost-effective sourcing and restoration methods without compromising the quality. Implement dynamic pricing strategies that consider the item's rarity, condition, and market demand. Streamlining operations and regularly reviewing financial performance can help identify areas for cost reduction and efficiency improvements.

Navigating these challenges requires a blend of strategic thinking, adaptability, and a deep understanding of both the antiques market and your customer base. By implementing thoughtful solutions and

continually refining your approach based on feedback and market developments, you can overcome obstacles and build a thriving antique business.

Strategies for Overcoming Obstacles

Overcoming obstacles in the antique business requires a blend of innovation, strategic planning, and a deep understanding of the market. Given the unique nature of dealing with historical items, each with its story and potential value fluctuations, antique dealers must navigate a range of challenges. Here are strategies designed to tackle these obstacles effectively.

Embracing Digital Transformation

Challenge: The rise of online sales and digital marketplaces has intensified competition and changed customer buying behaviors.

Strategy: Develop a robust online presence through an e-commerce platform, social media engagement, and digital marketing. Utilize online auctions, virtual showrooms, and storytelling through blogs and social media posts to connect with a global audience. Implementing SEO strategies and leveraging online advertising can also drive traffic to your digital platforms.

Authenticity Verification and Provenance Research

Challenge: Ensuring and proving the authenticity and provenance of items can be difficult but is crucial for maintaining credibility and customer trust.

Strategy: Invest in education and build a network of experts for consultation. Utilize technological tools like high-resolution imaging and databases for research. Offering detailed documentation and transparency about each item's background can also enhance buyer confidence.

Inventory Management and Diversification

Challenge: Managing a diverse inventory and adapting to changing market trends and customer preferences can be complex.

Strategy: Employ inventory management software tailored to the unique aspects of antique dealing. Regularly review and adjust your inventory based on sales data, market trends, and customer feedback. Diversify your inventory to cater to a broad range of tastes and budgets, reducing dependence on any single market segment.

Customer Engagement and Retention

Challenge: Building and maintaining a loyal customer base in a niche market.

Strategy: Offer personalized shopping experiences, utilize customer relationship management (CRM) tools to tailor communications, and engage customers through educational content and events. Implement loyalty programs or offer exclusive previews to returning customers to encourage repeat business.

Logistics and Shipping

Challenge: Safely shipping antiques, especially fragile or large items, poses significant risks and logistical challenges.

Strategy: Develop expertise in packaging techniques specific to antiques and use reputable shipping partners who offer insurance and tracking. For larger items, consider offering white-glove delivery services or facilitating local pickups.

Adapting to Market Trends

Challenge: The antique market is influenced by evolving trends, which can affect the demand for certain items.

Strategy: Stay informed about industry trends through market research, subscriptions to trade publications, and participation in antique forums and events. Be flexible in your acquisition strategy, and consider consignment or partnerships to access a wider range of items.

Financial Management

Challenge: Managing cash flow, especially with the high costs associated with acquiring, restoring, and maintaining inventory.

Strategy: Implement strict financial planning and monitoring, including budgeting, forecasting, and cash flow management. Explore multiple revenue streams, such as offering appraisal services, restoration, or hosting workshops, to supplement income from sales.

Legal and Regulatory Compliance

Challenge: Navigating the complex legal landscape related to the sale of antiques, including import/export restrictions and sales tax compliance.

Strategy: Stay informed about relevant laws and regulations, and consider consulting with legal experts specializing in art and antiques. Implement systems to ensure compliance in all aspects of your business, from online sales to international shipping.

Maintaining a Competitive Edge

Maintaining a competitive edge in the antique business demands a blend of deep historical knowledge, keen market insight, and a flair for storytelling. With the uniqueness of each piece and the deeply personal preferences of collectors, competition becomes not just about price but about providing value that transcends the item itself. Here's how you can stay ahead in this nuanced marketplace.

Cultivate Expertise: Your knowledge about the antiques you deal with is invaluable. Continue to educate yourself on the history, styles, makers, and restoration techniques. This expertise not only aids in sourcing and authenticating items but also enhances

customer trust and loyalty as you become a go-to source for information and quality pieces.

Embrace Digital Innovation: In today's market, a strong online presence is crucial. This doesn't just mean having a website or online store; it involves leveraging social media to tell the stories behind your items, engaging with customers through content marketing, and utilizing online auctions and marketplaces to reach a global audience. Digital tools can also help manage inventory, track sales, and analyze customer preferences more efficiently.

Offer Exceptional Customer Service: In a business where purchases are often significant and deeply personal, the customer service experience can be a key differentiator. Offer personalized shopping experiences, detailed provenance and care information for each piece, and follow-up communication to ensure satisfaction. A flexible approach to negotiations and returns can also set you apart from competitors.

Build a Strong Brand Identity: Your brand should reflect the unique character and quality of your inventory. This includes everything from your logo and website design to the way you describe your items and interact with customers. A strong, cohesive brand identity helps customers remember you and fosters a sense of loyalty.

Network and Collaborate: Building relationships with other dealers, collectors, and experts can open up new opportunities for sourcing items, learning about emerging trends, and collaborating on events or promotions. Participation in antique shows, fairs, and online forums can also enhance your visibility and reputation within the community.

Diversify Your Inventory: While specializing in a particular type or period can attract a dedicated clientele, offering a diverse range of items can appeal to a broader audience and protect your business from fluctuations in market demand. Keep an eye on emerging trends and be open to expanding your inventory to include new categories or styles.

Focus on Authenticity and Quality: In a market flooded with reproductions and items of dubious origin, authenticity and quality can set your business apart. Invest in thorough research and authentication for each piece, and be transparent about any restorations or repairs. Offering a guarantee of authenticity can also enhance customer confidence in your inventory.

Innovate and Adapt: The antiques market is constantly evolving, with shifts in customer preferences, economic conditions, and the way people shop. Stay adaptable, willing to innovate your business model, and explore new sales channels or marketing strategies.

Listening to customer feedback and staying informed about industry trends can help you pivot as needed to meet changing demands.

By focusing on these strategies, you can maintain a competitive edge in the antique business, attracting customers with your expertise, authenticity, and the unique value you provide. It's about creating an experience that resonates with buyers, building relationships that last, and continually adapting to thrive in this fascinating and ever-changing market.

Conclusion

Navigating the antique business encompasses a blend of passion for history and artistry, alongside savvy business strategies and a deep understanding of customer needs. Success in this niche market is not merely about the treasures you collect and sell but about how you connect those pieces with collectors, decorators, and enthusiasts who cherish them. By focusing on detailed knowledge, digital innovation, exceptional customer service, and a strong brand identity, you can carve out a distinctive niche in the competitive landscape.

The journey of managing an antique business is continuous and requires adaptability to changing market trends, customer preferences, and technological advancements. Cultivating expertise, embracing online platforms, and providing outstanding customer experiences are key to building and sustaining a loyal customer base. Additionally, exploring new revenue streams, managing inventory efficiently, and maintaining financial health are crucial for long-term growth and profitability.

Collaboration and networking play significant roles in expanding your reach and knowledge, offering mutual benefits that can lead to exciting opportunities. Overcoming common challenges in the antique business, such as fluctuating market demand and ensuring

the authenticity of pieces, demands perseverance and innovative problem-solving.

Maintaining a competitive edge requires a constant commitment to learning, innovation, and the pursuit of excellence. The unique stories behind each antique piece, combined with your expertise and passion, create a compelling narrative that can captivate a wide audience.

In conclusion, the antique business offers a rewarding venture for those who are passionate about preserving and sharing the beauty and history of the past. By employing strategic planning, embracing technology, and fostering genuine connections with your customers, you can build a thriving business that stands the test of time, ensuring that the legacy of the past enriches the future.

Encouragement for Future Antique Dealers

For those embarking on the journey of becoming antique dealers, it's a path filled with discovery, passion, and the potential for profound personal and professional satisfaction. The world of antiques is not just about objects but about the stories, history, and artistry they embody. As you step into this realm, here are some words of encouragement:

Embrace Your Passion: Your enthusiasm for antiques is your greatest asset. It will guide your learning, fuel your perseverance, and resonate with your customers. Let your passion shine through in every aspect of your business.

Stay Curious and Informed: The antique market is vast and ever-changing. Dedicate yourself to continuous learning—about history, art, market trends, and restoration techniques. This knowledge will not only enrich your own experience but also enhance the value you offer to your customers.

Build Meaningful Relationships: Connect with other dealers, collectors, and enthusiasts. These relationships will become a source of support, inspiration, and opportunity. Remember, the antique community thrives on shared passion and respect.

Embrace the Digital Age: Leverage online platforms to reach a broader audience, share your expertise, and showcase your collection. Digital tools can also streamline your operations and open up new avenues for growth.

Be Patient and Persistent: Success in the antique business may not come overnight. It takes time to build a reputation, cultivate a customer base, and develop an eye for valuable finds. Perseverance and resilience in the face of challenges will serve you well.

Focus on Authenticity and Quality: In a world where reproductions are common, authenticity and quality will set you apart. Invest in research and verification, and always be transparent with your customers about each item's history and condition.

Remember the Joy of Discovery: One of the greatest pleasures of the antique business is the thrill of the hunt—the moment you uncover a hidden gem or learn something new about a piece's history. Cherish these moments and let them fuel your journey.

Contribute to Preservation: As an antique dealer, you play a crucial role in preserving history and art for future generations. Take pride in this responsibility and the impact your work has on cultural preservation.

Be Open to Evolution: Your business, like the market itself, will evolve over time. Stay flexible, embrace innovation, and be open to new ideas and strategies that can enhance your business and personal growth.

The path of an antique dealer is as varied and fascinating as the items you will discover and sell. It offers the opportunity to turn a passion into a livelihood, to connect with the past in a tangible way, and to bring joy to others who share your love for antiques. Welcome to the journey, it promises to be an enriching and rewarding adventure.

www.ingramcontent.com/pod-product-compliance
Lightning Source LLC
Chambersburg PA
CBHW071917210526
45479CB00002B/451